PASSED TO THE PRESENT

FOLK ARTS ALONG WISCONSIN'S ETHNIC SETTLEMENT TRAIL

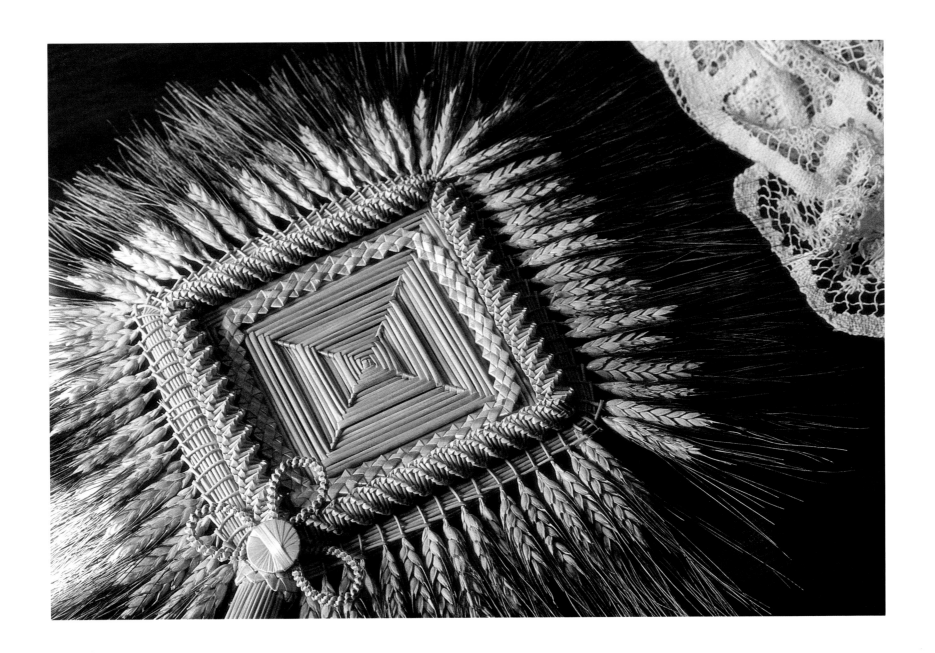

■ WHEAT WEAVING BY SIDONKA WADINA LEE.

PASSED TO THE PRESENT

FOLK ARTS ALONG WISCONSIN'S ETHNIC SETTLEMENT TRAIL

EDITED AND CURATED BY ROBERT T. TESKE

FIELD RESEARCH AND CATALOGUE ESSAYS BY JAMES P. LEARY AND MARY A. ZWOLINSKI

PHOTOGRAPHY BY LEWIS KOCH

A TRAVELING EXHIBITION ORGANIZED BY THE CEDARBURG CULTURAL CENTER IN COOPERATION WITH WISCONSIN'S ETHNIC SETTLEMENT TRAIL, INC.

FUNDED IN PART BY GRANTS FROM THE NATIONAL ENDOWMENT FOR THE ARTS AND THE LILA WALLACE-READER'S DIGEST COMMUNITY FOLKLIFE PROGRAM

EXHIBITION TOUR

JANUARY 27–FEBRUARY 27, 1994	UNIVERSITY OF WISCONSIN-MILWAUKEE ART MUSEUM
MARCH 13–JUNE 19, 1994	OSHKOSH PUBLIC MUSEUM
JULY 3–AUGUST 14, 1994	MEAD PUBLIC LIBRARY, SHEBOYGAN
SEPTEMBER 18–NOVEMBER 20, 1994	CEDARBURG CULTURAL CENTER
JANUARY 29–MARCH 15, 1995	MILLER ART CENTER, STURGEON BAY
JUNE 4–JULY 16, 1995	NEVILLE PUBLIC MUSEUM OF BROWN COUNTY, GREEN BAY

CONTENTS

ACKNOWLEDGMENTS

The Cedarburg Cultural Center could not have successfully organized and presented a traveling exhibition of the size and scope of PASSED TO THE PRESENT without the generous assistance and cooperation of a number of committed individuals and collaborating organizations. The Cultural Center's Board of Directors wishes to extend its sincere appreciation to the many who have helped our organization complete this complex and challenging project.

First of all, we wish to thank the Folk Arts Program of the National Endowment for the Arts and the Lila Wallace–Reader's Digest Community Folklife Program for the generous funding support they provided for PASSED TO THE PRESENT.

Secondly, we wish to acknowledge the extraordinary field research carried out in preparation for the exhibition by folklorists James P. Leary, Janet C. Gilmore, and Mary A. Zwolinski and by photographer Lewis Koch. The text and illustrations which make up the exhibition and its accompanying catalogue are the direct result of their skillful efforts to identify and document traditional artists along Wisconsin's Ethnic Settlement Trail. We also wish to thank Victor DiCristo of Cedarburg for contributing his exceptional talents to designing this publication.

Thirdly, the Board of Directors of the Cedarburg Cultural Center wishes to thank the many organizations and institutions throughout eastern Wisconsin which have assisted in various ways with the development and presentation of PASSED TO THE PRESENT. Special thanks are due to Wisconsin's Ethnic Settlement Trail, Inc. for providing the foundation upon which the exhibit is based. Alan Pape, W.E.S.T. Project Consultant, has generously shared his extensive knowledge of Wisconsin's folk architecture and ethnic culture with the Center's staff and has lent his enthusiastic support to all phases of the project. Thanks are also due to Alma Radke and Jose Martinez of the United Community Center of Milwaukee, to Richard March of the Wisconsin Arts Board, and to the International Institute of Milwaukee for their assistance in contacting traditional artists.

Fourthly, the Cultural Center Board wishes to thank our dedicated staff for their commitment to providing Cedarburg and Wisconsin with the finest in multicultural programming. To Bob Teske, Cathreen Clark, Jill Bault, Laura Neese, Christine Bruss and Dick Ellefson, our heartfelt thanks.

Finally, the Cedarburg Cultural Center wishes to extend its sincerest thanks to the folk artists of eastern Wisconsin's ethnic communities whose exceptional work is the reason for this exhibition. For their time and their dedication, for their kindness and consideration, and for all they do to maintain the exciting variety of life here in Wisconsin, we thank them sincerely.

James L. Meinert
President/Board of Directors
Cedarburg Cultural Center

PREFACE

Wisconsin's Ethnic Settlement Trail (W.E.S.T.) was organized in 1990 as part of the State of Wisconsin's Heritage Tourism Initiative. A twelve county, 200 mile long corridor along Lake Michigan was chosen for this project because it contained the largest concentration of nineteenth century ethnic groups in the United States. Within this region over twenty different Old World settlements are to be found, as well as dozens of ethnic organizations. Forty percent of Wisconsin's population also lives within this region and supports an already-healthy tourism industry.

W.E.S.T. is also an outgrowth of Old World Wisconsin, the ethnic outdoor museum operated by the State Historical Society of Wisconsin near Eagle in western Waukesha County. However, instead of preserving buildings by moving them to a central location as in the case of Old World Wisconsin, W.E.S.T. promotes the restoration of buildings and landscapes on their original locations by the ethnic communities which created them in the first place. By creating a series of locally designated ethnic loop tours that branch off of a central corridor, and by identifying the best ethnic sites, ethnic craftspersons, and ethnic organizations in an area, W.E.S.T. hopes to guide visitors to high quality, enjoyable tourism destinations.

During a three year organizational period under the sponsorship of the Wisconsin Tourism Office, W.E.S.T. members have learned how to identify various tourism resources in their communities, including ethnic lodgings, gift sales, food services, interpretation opportunities, and promotional events. W.E.S.T. members have also learned historic restoration techniques, approaches to agricultural tourism, and methods for forming ethnic artisan associations. A "Getting Started Workbook" was even created to help train new members in the techniques of ethnic tourism development.

In 1993 and 1994, with the designation of a 154 mile driving route as the "Green Bay Ethnic Trail," W.E.S.T. brought ethnic tourism to eastern Wisconsin. The clearly marked trail, coupled with a seventy-page *Visitor's Guide to Wisconsin's Ethnic Settlement Trail* which includes eighteen separate tours, offer visitors a convenient introduction to the ethnic neighborhoods of eastern Wisconsin. Milwaukee's historic Turner Hall now houses the first Gateway Heritage Center along the Green Bay Ethnic Trail. Outlets offering quality ethnic goods, crafts and lodging are joining W.E.S.T. in promoting this significant tourism resource. Local historical societies, village and city governments, and chambers of commerce are also seeing the potential of this regional development and promotion effort.

The exhibition PASSED TO THE PRESENT: FOLK ARTS ALONG WISCONSIN'S ETHNIC SETTLEMENT TRAIL has identified a great many artisans who clearly demonstrate that ethnic traditions are alive in our region. These traditions form an interesting mosaic of ethnic form and color that reflect ancient cultures. The artisans who practice them are part of the reason visitors want to come to Wisconsin–to see and experience things not available in their home areas. Our visitors want to see ethnic artists practicing their crafts, meet them personally, learn from them, and bring back home with them items of ethnic origin.

Tourism is an industry which can promote our cherished traditions in new and beneficial ways. Wisconsin's Ethnic Settlement Trail, Inc. joins the Cedarburg Cultural Center in celebrating the presentation of PASSED TO THE PRESENT: FOLK ARTS ALONG WISCONSIN'S ETHNIC SETTLEMENT TRAIL.

Alan C. Pape Carol Rittenhouse Hoppe
Project Consultant President/Project Manager
W.E.S.T. W.E.S.T.

■ BELGIAN FARMSTEAD, SOUTH OF ROSIERE, DOOR COUNTY.

PASSED TO THE PRESENT:

FOLK ARTS ALONG WISCONSIN'S ETHNIC SETTLEMENT TRAIL

BY ROBERT T. TESKE

For more than one hundred and fifty years, Wisconsin's Lake Michigan shoreline has been the final destination of a wide variety of immigrant groups. As early as the 1830s, the Oneida–an Iroquoian people from New York State–left behind their eastern homeland for the woodlands of Wisconsin. The relocation of this small group of Native Americans was merely a prelude, however, to the enormous influx of Old World immigrants who were to make their way to Wisconsin over the last two-thirds of the nineteenth century. By 1850, two short years after Wisconsin achieved statehood, about 36 percent of the state's total population was foreign born. During the next fifty years, more than a million European immigrants from over thirty ethnic groups, including some 250,000 Germans, came to call "Wiskonsin, U.S.A." their home.

While the flood tide of immigration to eastern Wisconsin abated somewhat following the turn of the twentieth century, substantial numbers of immigrants from Europe, from other parts of the world, and even from other parts of the United States have continued to flow into the region over the last ninety years. European immigrants, African-Americans from the Deep South, Hispanic populations from Mexico and Puerto Rico, and Hmong refugees from the mountains of northern Laos have taken up residence in sizeable numbers along Wisconsin's Lake Michigan shore.

12

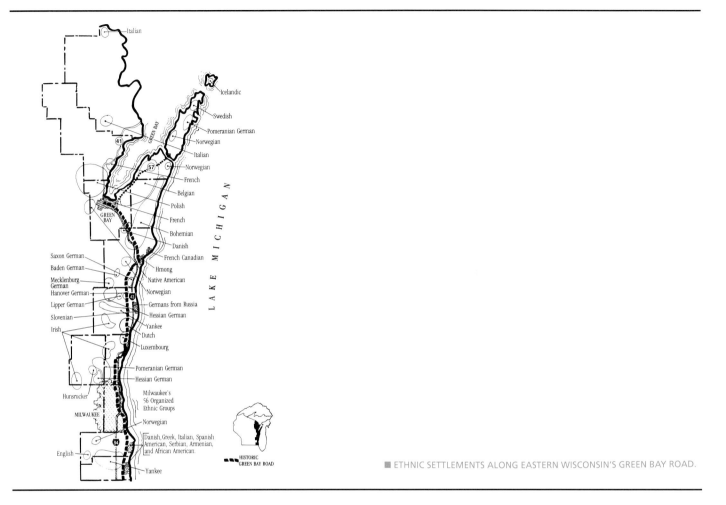

Italian
Icelandic
Swedish
Pomeranian German
Norwegian
Italian
Norwegian
French
Belgian
Polish
French
Bohemian
Danish
French Canadian
Hmong
Native American
Norwegian
Germans from Russia
Hessian German
Yankee
Dutch
Luxembourg
Pomeranian German
Hessian German

Saxon German
Baden German
Mecklenburg German
Hanover German
Lipper German
Slovenian
Irish

Hunsrucker

MILWAUKEE

Norwegian

Danish, Greek, Italian, Spanish American, Serbian, Armenian, and African American.

English

Yankee

Milwaukee's 56 Organized Ethnic Groups

GREEN BAY

L A K E M I C H I G A N

HISTORIC GREEN BAY ROAD

■ ETHNIC SETTLEMENTS ALONG EASTERN WISCONSIN'S GREEN BAY ROAD.

Over a century and a half of continuous immigration has exerted a pronounced influence upon eastern Wisconsin. The many ethnic groups which found their way to the region brought with them a variety of time-tested solutions to such basic problems as providing shelter, food, and clothing. Despite finding themselves in a new land, most of the ethnic communities turned to these long-established traditional techniques to meet their fundamental needs. Germans in Ozaukee and Washington Counties utilized log, stone, and *fachwerk*, or "half-timbered," building methods to erect homes, barns, and other structures. Bohemians in Manitowoc and Kewaunee Counties fashioned sturdy baskets like those they had used for many years in their homeland to haul feed for the cattle, gather eggs, and perform other chores. And "Hollanders" in Sheboygan County continued for many years to carve and wear the wooden shoes they had known in Europe for working on the farm.

Some of the traditions brought to eastern Wisconsin by ethnic settlers have taken root in the state's rich soil. The Hollandtown *schut,* an annual display of marksmanship put on by Dutch Catholic members of the community's St. Francis Society, has been held every year since 1849. Other traditions have been substantially altered during the course of their time in Wisconsin. Priscilla Manders' Oneida cornhusk dolls, for example, have not remained stiff and straight but instead have taken on poses representative of traditional activities, modeling for young members of the tribe their traditional way of life. Still other ethnic traditions brought to eastern Wisconsin many years ago have passed out of their communities of origin and are maintained by committed outsiders. Thus, Bob Siegel, Jr. continues the tradition of Dutch wooden shoemaking and John Arendt the tradition of Bohemian basketmaking though both of them are of German extraction.

While there has been a degree of evolution and change in the folk arts and crafts, folk customs, and folk architecture of the region, the richness and diversity of eastern Wisconsin's ethnic heritage continues to shape and structure life in the area. Today, over twenty distinctive ethnic communities still line the old settlement route from Kenosha to Green Bay, forming the largest concentration of nineteenth century ethnic enclaves anywhere in the country.

This unique configuration of ethnic communities led to the organization in 1990 of an innovative historic preservation project designed to save the folk architecture of the region and to support and celebrate its traditional customs, crafts and celebrations. Dubbed "Wisconsin's Ethnic Settlement Trail" by its developers, the project set as its goal the creation of a two hundred mile long driving and bicycling route through twelve Wisconsin lakeshore counties. Side trips along the main trail introduce visitors to ethnic lifestyles, foods, farmsteads, and communities dating to the 1830s. At each of these locations, local museums, historical societies and community organizations offer programs which not only serve as educational tools, but also help to increase visitation to the region and serve as catalysts for economic development.

In order to complement the efforts of W.E.S.T. to preserve the ethnic heritage of eastern Wisconsin, the Cedarburg Cultural Center has developed the traveling exhibition PASSED TO THE PRESENT. By focusing on the smaller, more ephemeral forms of folk art still practiced in thirteen selected ethnic communities, the Cultural Center hopes to assist W.E.S.T. in expanding its focus beyond traditional architecture and to fulfill its own mission of documenting and interpreting the region's history and cultural heritage. Most importantly, however, PASSED TO THE PRESENT: FOLK ARTS ALONG WISCONSIN'S ETHNIC SETTLEMENT TRAIL seeks to recognize and assist the folk artists of eastern Wisconsin's ethnic communities, whose exceptional artistry, creativity and dedication have contributed to their communities' continuing sense of identity and pride.

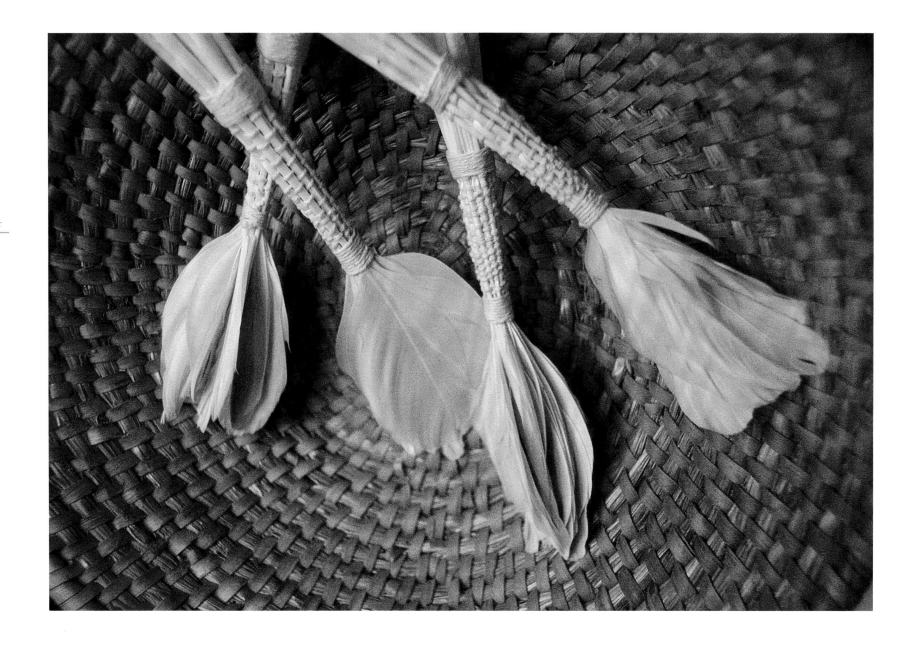

■ BOHEMIAN GOOSE-FEATHER PASTRY BRUSHES BY MARTHA KLIMENT WAGNER OF MANITOWOC.

ETHNIC CRAFTS AND RURAL LIFE:

SUBSISTENCE, CEREMONY, AND SYMBOLISM

BY JAMES P. LEARY

From Milwaukee to Marinette the rural and village landscape is enlivened by graveyards, churches, halls, houses, and barns that bear venerable witness to the diversity and skills of eastern Wisconsin's indigenous and ethnic peoples. The Wisconsin Ethnic Settlement Trail invites us to traverse this cultural landscape; to ponder bark, log, frame, brick, and stone; to recall the various builders; and to distinguish what is Belgian, Oneida, or Pomeranian about their work. Such imposing traditional architecture rightly commands interest, but it can also prompt consideration of folk artistry on a smaller scale.

Treasured because of their beauty, their age, and their increasing scarcity, the ethnically distinctive structures dotting the farms and small towns of eastern Wisconsin are but one end of a continuum of craft skills begun in kitchen and parlor, in shop and barnyard. And while the old time knowledge of constructing a longhouse, a bake oven, or a threshing barn may have substantially faded through the generations, the secrets of making a cornhusk doll, a holiday pastry, or a feed basket have often been passed from the settlers' era to the present. Indeed the persistence of craft traditions offers important insights into the evolution of cultures along Wisconsin's Ethnic Settlement Trail.

The region's early settlers were fundamentally crafters of necessity. Whether an indigenous Menominee or Winnebago, a refugee Oneida, or one of an array of immigrant Europeans, a mid-nineteenth century dweller in eastern Wisconsin had little choice but to rely on his or her own skills, or those of neighbors, especially with regard to clothing and many artifacts of the farm and household. Typically women toiled with needles, threads, and fabric, while men worked wood with knives and chisels. Some raw materials were acquired from afar through purchase or trade, others were raised on farms or harvested from the wild. Moreover, the techniques and patterns through which raw materials became finished were often strikingly similar from one ethnic group to another, but just as often they differed in ways both subtle and apparent.

Representative accounts persist in the historical record. In Oconto County's village of Lena, the French women "liked to weave cloth and rugs, and quilting bees were a great pastime for them" (Hood 1948). Sheboygan County's Dutch, like most European immigrants, raised sheep. "From the wool the housewife knitted stockings and wove the homespun for the family clothing" (Rederus 1918:259). The Czechs or Bohemians of Two Creeks in Manitowoc County relied

on the handmade spinning wheels of settler John Mattek for "making yarn to be knitted into mittens, socks, scarfs, and jackets" (Wojta 1944:423). They also kept geese.

> *Feather stripping bees—a strictly woman's affair—were all the rage in rural homes during winter evenings. The geese and duck feathers were used for stuffing pillows and feather-beds. Stripping, gossiping, and eating made up the entertainment (Wojta 1944:425).*

Some Flemish women east of Green Bay in Brown County raised geese not only for their own use, but "for the sale of feathers." To command a higher price, they practiced live-plucking. "An old stocking was pulled over the goose's head to keep it from pecking, then the legs were tied together and the feathers were removed" (Rentmeester 1985:73).

The farmers who pitched manure, cut marsh hay, and trod muddy fields found shoe leather dear and often made or swapped for cheap, durable wooden shoes. The Dutch or Hollanders, who brought tools and know-how from the old country, are best known today for this tradition, but eastern Wisconsin's Germans, Norwegians, Czechs, and Belgians had their own variations. Of the immigrants in Two Creeks, J. F. Wojta noted:

> *Customs from their parent countries were frequently inaugurated, often out of necessity. For instance John Last, August Kraase, Fred Messman, and others, who came from Germany, brought with them the art of making Pantoffeln, a kind of wooden slipper. The bottoms were carved out of basswood or pine blocks because of the ease with which the wood could be manipulated, and leather vamps were attached to these bottoms. The shoes were light to carry and were put on and removed with little effort. They were used in doing chores and a neat pair was quite commonly worn about the house (1944:422-423).*

The wooden shoes or *sabots* of southern Door County's Walloon Belgians were equally common and versatile.

> *When plowing, they wore them without socks, for the sabots soon filled up with loose soil. Being warm and dry they were also worn in winter when logging or working around the sawmills. They then tacked on long canvas leggings which made cheap and serviceable footwear. The sabots of the women were cut lower than those of the men, and they were fastened on the foot with a strap above the instep. A few could even dance with them but that was exceptional. In those days there were many wooden-*

> *shoemakers, and they often produced very artistic sabots beautifully carved and colored (Holand 1933:52-53).*

The ethnic distinctions in wooden shoes occasionally extended to such ubiquitous and mundane objects as hand tools for cultivation. While visiting the Luxembourgers of Ozaukee County, the journalist Fred Holmes noted a garden tool "made and used by them that I found among no other immigrant group. It was a heavy hoe, more like a pick-ax, that could be used for grubbing and loosening the earth" (Holmes 1944:83).

Driven by the necessity of subsistence in cash-scarce times, many ethnic handicrafts were nonetheless imbued with aesthetic and ritual significance. The beauty of deftly knit mittens, downy pillows with embroidered cases, well-turned spinning wheels, and "beautifully carved and colored" *sabots* rendered satisfaction to their makers and admiration from the surrounding community. Some youthful crafters even attracted potential mates with their skills—competent handwork was, after all, essential to a farm couple's success.

The elevation of craft skills beyond the level of everyday utility was and continues to be particularly evident in artifacts made chiefly for ceremonial reasons—for occasional purposes of spiritual and celebratory expression that are aligned with the seasons of the agricultural year.

Many Walloon Belgian Catholics, for example, constructed wayside chapels along the roads that passed their rural homes. Roughly 8' x 10', of wood frame construction, with an altar adorned with images of Jesus and various saints, these chapels were often built in memory of a departed loved one, and were used for community and family prayer (Holand 1933:95-96; Tishler and Brynildson 1986:79). In a memoir offered to her granddaughter, Josephine LeGreve of Brussels, Wisconsin, recalled:

> *We lived one mile from church, and most of the time we walked that mile. On the way to church there was a small chapel… People used to put them up in one corner of their land. There were little services at these chapels and they would say the rosary, always praying to the Blessed Mother (Huber 1988:4-5).*

Rosary services were most commonly in May when people carried fresh flowers in processions to adorn the chapels. Some Polish Catholics likewise followed old country tradition by erecting crossroad shrines for individual worship and collective visitation during the spring Rogation Day processions to bless farmers' seeds. The restored Ryczkowski shrine, built in 1901 just north of Pulaski, is a brick pedestal topped by

■ BELGIAN ROADSIDE SHRINE, RED RIVER TOWNSHIP, KEWAUNEE COUNTY.

■ JOHN COPPES, KING OF HOLLANDTOWN'S 75TH ANNUAL *SCHUT* IN 1925, SURROUNDED BY WOMEN IN DUTCH COSTUME.

sheltered images of the Virgin Mary and that patron of the natural world, St. Francis of Assisi.

When Dutch Catholics settled Brown County's Hollandtown in 1848, they called the place Franciscan Bosh, after their Franciscan priest, Father Gothart. The immigrants soon organized a benevolent St. Francis Society and, on October 4, instituted their first *schut*. A medieval European village tradition rooted in notions of "holy warriors" defending their community, the Hollandtown *schut* begins with a Sunday mass, followed by a procession to a park west of the village. The parish priest offers a prayer, then a succession of marksmen and women take aim at a "bird" placed atop an 80' tower. The bird is the replica of a parrot–a previously unknown fowl to the crusaders who brought parrots home from the Holy Land. Naturally the bird is destroyed each year and must be made anew by a local craftsman, nowadays Paul Vander Loop. The shootist, who dislodges the bird to become "king," is presented with a cape, likewise made locally. Then the entire community adjourns to Van Abel's Hall for a dinner, a dance, and the viewing of elaborately handcrafted medals won by prior *schut* kings.

The cornhusk dolls made amidst fall harvests by Wisconsin's Oneida people may serve as children's playthings, but they are also tangible reminders of the importance of corn as both an essential food and a generous spirit. Priscilla Manders, who learned to make the dolls while husking corn with her grandfather, cannot think of them apart from the story he told. In it, after the people had left a husking bee,

the corn dolls came to life. One saw her face in a puddle and became conceited toward other dolls. In punishment, the Creator took her face, her spirit, and set her wandering. After unsuccessfully asking several animals to help her, the doll forgot her predicament to help a butterfly water a corn field so that the Indians would have food. The Creator restored the doll's face and spirit. In moral terms, the corn doll embodies humility and communal dedication.

The Slavic peoples of eastern Wisconsin crafted similar reminders of spiritual values as part of Christmas and Easter observances. Poles, who had settled on cutover land after toiling in Pennsylvania mines and Chicago factories, decorated Christmas eve tables with straw centerpieces reminiscent of the Christ Child's manger; pointed paper stars recalled the Star of Bethlehem. Betty Piso Christenson, on a homestead near Suring in Oconto County, delighted in more than the design and color of her Ukrainian-born mother's Easter eggs. The eggs conjured a larger world of ceremony and meaning. She learned, for example, that, to ensure a bountiful harvest, her grandparents put an egg with an image of wheat in the last furrow plowed in spring. They were just "plain peasants. They were hardworking people, and the only way to express their feelings, and their beliefs, and their religion, was to put it on an egg."

The habit of utilitarian and ceremonial craft traditions, established among eastern Wisconsin's ethnic settlers of the 1800s, remained the rule in the region's rural areas and villages through the first half of

18

"great quilters." After a quilt was finished:

We could say, "Oh this was my dress, this was George's shirt, this piece comes from someplace else." There were memories connected with all those quilts.

Quilting bees with neighbors were common at the Carriveau home through the 1920s, and the stitchery was admirable: "just the end of the needle would go in and up again." In the 1990s, Betty Sherman continues to quilt, not because she wants for warm blankets, but because she wants to convey the meaning of the youthful experiences she prized so highly. She has given more than a score of quilts to her children and relatives. She doubts her stitches are as fine as Mary Theodore's, but "my children love them and put them on their beds only for company."

As a young girl in rural Manitowoc County, Martha Kliment Wagner (b. 1906) mastered a wide range of essential farm skills, among them the ability to fashion goose-feather brushes. Her family, and those of all the neighbors, kept geese for food and feathers. The down from feathers, stripped during winter bees, filled pillows and feather ticks, and provided a source of cash when sold to Chicago markets. Clusters of short feathers, with stripped stems, were also bound with strong string to make pastry brushes called *perotky* (little feathers). Typically used in baking, one brush served to grease a pan, while the other was used to spread the egg whites that give breads a light brown sheen. Larger wing feathers were placed in a bag, then hung in a shed to dry for a year. When trimmed and fitted at the base with a cloth handle,

this century. And, in some instances, it continues to the present. Those who carry on, however, have been doing so increasingly on their own and for their own reasons. The region has changed around them, has become modernized, homogenized, Americanized. No longer compelled by necessity and no longer participants in a world dominated by ethnically based ceremony, they maintain their inherited traditions for reasons of individual self-expression, ancestral fealty, and cultural identity. Consequently, they have often become curators of and advocates for their traditions. And in so doing, they have come to work outside earlier contexts of family subsistence and community ceremony, to treat their crafts as heirlooms: reminders of what has been, objects resonant with symbolic power.

Born in 1908 in Oconto Falls, Betty Carriveau Sherman grew up in a French extended family. Her father, Joe, a farmer and stonemason, was also a superb teller of old time French trickster tales. He told his stories only amidst blizzards when the children would gather around the family's wood stove, perhaps warmed by a homemade quilt. Betty's mother and a paternal aunt, Mary Theodore Carriveau, were

they served as dusters for cobwebs or to sweep out the ashes from a wood stove. If well-made and properly cared for, these brushes could last for decades. Indeed Martha Wagner has a pair of wing dusters more than sixty years old. "I haven't used them recently because I want them to last." Like a set of painted plates from Czechoslovakia that decorate her kitchen's shelf, they are symbols of her ethnic heritage. More importantly, they are *her* symbols, made "to last" by her own hands.

Among the youngest of the Green Bay area's "old breed" of woodworkers and waterfowlers, Patrick Farrell was born into an Irish working class family in 1942. He "chummed" with the sons of boat-builders, commercial fishers, and hunters of various Belgian, German, and Scandinavian extraction.

> *We played in boats with ducks and decoys and saw old men carve them with hatchets and coping saws. So when I reached the age, ten-eleven years old, I started to be interested in hunting. And the only way for a guy without money to have decoys was to make them myself. Got an old cedar pole, split it in half, took a hatchet, and started chopping around to make it look like a decoy. Brought the birds in, killed a lot of ducks over it. That was years ago. Now there isn't that many ducks.*

Green Bay is no longer what it was. Sloughs and wetlands have been filled in and covered over for roads and housing developments. Changing water levels and storms have wiped out bogs and islands. Fly ash from the power plant has fouled habitats, and both fish and waterfowl have suffered from pesticides and pollution. Yet Pat Farrell continues to make hunting skiffs and the occasional decoy in the old way–not for money, not to hunt over, but out of a commitment to the work itself, his memories of hunting on the Bay, and an affection for "old timers," like John Basteyns and Ted Thyrion, from whom he learned.

Once compelled by the necessity of subsistence, once integrated with the religious ceremonies of an agrarian community, the ethnic crafts of rural eastern Wisconsin have grown scarce but no less significant. By stubbornly choosing to do what they do, contemporary practitioners of old time ethnic crafts fuse the past with the present in ways which are both tangible and intangible, both actual and symbolic. In a world of mass production and endless choice, where the new continuously beckons, the old still retains power by virtue of its grounding in the earth, the seasons, and the ancestors.

SOURCES

Note: All quotations and information from ethnic craftspersons are based upon tape recorded interviews conducted by James P. Leary for the Cedarburg Cultural Center's Wisconsin Ethnic Settlement Trail project in Summer, 1993.

Holand, Hjalmer Rued. *Wisconsin's Belgian Community.* Sturgeon Bay: Door County Historical Society, 1933.

Holmes, Fred L. *Old World Wisconsin. Around Europe in the Badger State.* Eau Claire: E.M. Hale, 1944.

Hood, Abbie Jane. *Oconto County Centennial Magazine.* Oconto: The Oconto County Reporter, 1948.

Huber, Margaret. "Grandma Grew Up in Brussels, Wisconsin." Student paper for Folklore of Wisconsin course at the University of Wisconsin, Summer 1988.

Metzner, Lee. "The Belgians in the North Country." *Wisconsin Magazine of History* 26:3 (March 1943):280-288.

Rederus, Sipko F. "The Dutch Settlements of Sheboygan County." *Wisconsin Magazine of History* 1:3 (March 1918):256-265.

Rentmeester, Jeanne and Les. *The Flemish in Wisconsin.* 1985.

Tishler, William H. and Erik Brynildson. *The Architecture and Landscape Characteristics of Rural Belgian Settlement in Northeastern Wisconsin.* Madison: UW Department of Landscape Architecture, 1986.

Wojta, J. F. "Town of Two Creeks, From Forest to Dairy Farms." *Wisconsin Magazine of History* 27:4 (June 1944):420-433.

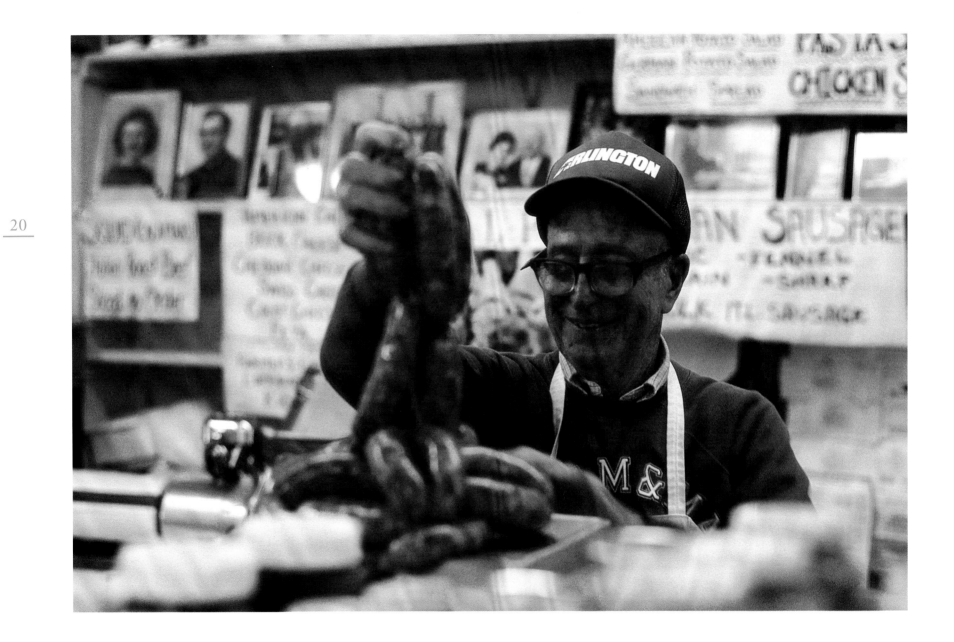

■ GROPPI'S ITALIAN MARKET, MILWAUKEE.

ETHNIC IDENTITY AND URBAN LIFE IN SOUTHEASTERN WISCONSIN

BY MARY A. ZWOLINSKI

Historically, cities have always offered great potential for and prompted great anticipation among newly arrived immigrants. Although they never found the proverbial streets paved with gold, many immigrants were able to find jobs in factories, foundries, mills and shops that would become the economic basis of their new lives. Cities also offered ethnic communities neighborhoods that provided immigrants with a sense of "home," and a feeling, if only temporarily, of security. Within southeastern Wisconsin's urban areas, ethnic communities grew, prospered and thrived. The communities eventually shaped the cities.

Those cities, in turn, also played an important role in shaping the ethnic groups themselves. People fleeing war, famine, or political and religious persecution in Asia, Europe, or Central and Latin America arrived in Wisconsin cities to rebuild their lives. They structured their lives on their traditional folkways. The process of moving to a new country involved negotiations between old ways and new ways of doing things. For many immigrants, the transformation from previous rural homes to their new urban homes meant changing and adapting the traditions that they brought with them.

Cities still provide immigrants with a blank canvas on which to outline new lives. Distinct ethnic groups leave their mark on the urban landscape in yard shrines, churches, gardens, storefronts and the architecture of fraternal lodges and social clubs. Such visual expressions help distinguish one ethnic group's boundaries from another's. Today, Wisconsin's urban centers are among the richest and most diverse sources of traditional ethnic life in the United States.

In Sheboygan, one of the state's largest populations of Hmong continues to live in extended families and community clusters. They began settling in Wisconsin in the early 1980's after fleeing Southeast Asia during the war. Most of the Hmong refugees lived in camps before finally resettling in established communities. Many aspects of community members' lives have changed, including their adjustment to urban life from the agrarian lifestyle most of them knew. But some aspects of their lives remain intact. Hmong needleworkers continue to make *paj ntaub*. While their designs and motifs remain traditional, the colors they use and the types of things they make have changed to satisfy an American, or non-Hmong, market.

■ HMONG BURIAL ROBE BY XAO YANG LEE RESTS ON AN EXAMPLE OF HER *PAJ NTAUB*.

In Milwaukee, European immigrants from Germany, Poland, and Czechoslovakia came in great numbers in the late 19th and early 20th centuries to work in foundries, breweries and shops. They created distinct ethnic subcultures from the south side to the north side. Their presence, and the maintenance and display of their traditional arts, celebrations, languages and foodways, have become important defining characteristics of Milwaukee, which community leaders promote as "Old World." Today, newer immigrant communities of Hispanics, Mexicanos and Tejanos have also formed a tightly knit community on the south side.

In Racine, two long-standing Armenian churches offered a sense of stability following the devastating genocide of Armenians by the Turkish in the early part of the century. Through public presentations and education, the churches merge religious and ethnic life, struggling to maintain Armenian traditional culture and language. The success of their efforts is cause for celebration.

But urban areas can also contribute to instability in ethnic communities. Gentrification, suburbanization and self-conscious attempts at Americanization often wreak havoc on tightly-knit ethnic neighborhoods, as do the displacement of community members, the breakup of church congregations, or the failure of small, family owned businesses. This breakdown, or just the threat of it, can necessitate an even greater desire for the maintenance of traditions through more choreographed events like picnics, festivals and social gatherings that offer a "reunion" to displaced communities. Ethnic celebrations are a means of educating others about the group and of informing younger generations about their own ethnic traditions. Often, the traditions of a city's ethnic groups are used as promotional devices for the attraction of tourists and tourist dollars.

■ HOLLANDFEST IN CEDAR GROVE SHOWCASES DUTCH FOLK CULTURE FOR THE GENERAL PUBLIC.

23

FESTIVALS, PICNICS AND OTHER CULTURAL DISPLAYS

Each summer, Milwaukee's Henry Maier Festival Park becomes an almost continuous celebration of ethnic festivals, directed by the organization World Festivals, Incorporated. African-American, Italian, Irish, Polish, and Mexican festivals and other gatherings are created to attract residents and visitors to share in Milwaukee's ethnic diversity. Thousands of people participate through music, dance, art and food. Ethnic communities and social organizations participate in these summer festivals, but the events are purposely created to entertain and educate thousands of people outside of the featured ethnic group. Combining traditional displays with non-traditional types of activities and foods, these festivals introduce people to the generalities of ethnic life without the responsibility of having to learn the specific histories, languages or traditions. Their enormous success lies in the fact that people everywhere are interested in other people, in ethnic foods and music; the adaptation of a regular "festival" to one that uses ethnicity as its theme and focal point is attractive. It also allows people from the participating community to decide what will be displayed and celebrated and what is too complex, unfamiliar or too politically hazardous to recreate for outsiders.

On a smaller scale, local ethnic festivals are also designed to introduce outsiders to the traditions. In Waukesha, an annual Latino festival celebrates the traditions of a group of people who have lived in Waukesha since the 1930's, but whose traditions and language are distinctly different from the area's Yankee and European populations. Not only as a way of making their presence known, but as a way of celebrating their integration into community life, the Latino festival invites all people to share in their traditions. They are not only celebrating Hispanic life and culture, but sharing those traditions with friends and neighbors.

St. Mesrop's Armenian church in Racine holds its festival each year, downtown at the lakefront in Festival Park. This previously small gathering has now become one of Racine's largest and most successful festivals. St. Mesrop's festival has moved beyond the small intimate church picnic it once was and now attracts more non-Armenians than Armenians. Traditional Armenian foods, shish-kebabs, pilaf and sarma (stuffed grape leaves), are served alongside more traditional festival foods. A local band, the Mid East Beat plays Armenian music, and festival participants dance in the traditional line. Inside the hall, information about the traditions is displayed on tables, along with other foods, a children's area and a stage that showcases Armenian arts from other parts of the country. St. Mesrop's festival is an opportunity to learn more about a distinctive cultural group that has lived in the area for generations, but for those who are not interested in learning about Armenian culture, the location of the festival and the various other activities offered create a regular festival experience.

St. Hagop's Armenian church in Racine, however, maintains its annual *madagh* at Racine's Johnson Park. The crowd is smaller, and the events are specifically Armenian. The music and dancing proves especially popular among some of the younger Armenians. A large meal (the *madagh*) is prepared outside over fires, blessed by the church priest during a regular mass service held at the park, and then served to anybody who wants to wait in line. The meal consists of a lamb stew served over bulgar pilaf, cooked in large kettles. The preparation of the *madagh* recalls a different time and place in the cultural past of Armenians. Picnickers bring their own utensils, salads and desserts. A small pavilion sells beer and soda and is the center of socializing for the picnickers.

While these two picnics are different in terms of audience, their main goal, to make money for their respective churches, is the same. The larger of the two churches has taken their successful picnic and gone "public" with it, while the smaller church maintains the picnic atmosphere of their annual event, attracting primarily church members and their extended families and friends.

NOSTALGIA AND TRADITION

At Trgatav Park, in Racine County, members of Milwaukee's Slovenian community gather each year for summer weekends of picnicking with friends. Many members of the community came to Milwaukee in the late 1940's and early 1950's, fleeing communism and the political upheavals occurring in most of eastern Europe at that time. They settled into jobs and developed trades, raised their families and attended churches on the west and south sides.

Woodcarver John Bambic came to Milwaukee from a rural area of Slovenia, Yugoslavia in 1950. After taking a job at the Pfister Vogel Tannery, he began to socialize with other Slovenians in the community. Together they purchased a piece of land in rural Racine County

■ SLOVENIAN GRAPE HARVEST FESTIVAL AT TRGATAV PARK, NEAR WIND LAKE.

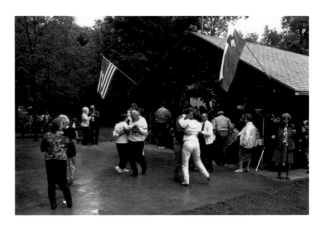

as a weekend vacation spot. Some people built small cottages on the property and collectively they built a pavilion with a dining area, kitchen and bar. John and other Slovenians of the community continue to travel the 20 miles to their rural camp for picnics and informal get-togethers At the camp John finds the linden wood he uses to carve his whirligigs. These wooden constructions depict scenes of rural life that he recalls from Slovenia. Butcher shops, woodcarvers, barrel makers, and bakers all are reminiscent of a life faraway from Milwaukee. John's whirligigs are popular among his friends who keep apprised of his work through the gatherings at the park.

Trgatav Park also serves another function. It is used for the recreation of Slovenian rituals and traditions that were not normally part of immigrant life in Milwaukee. Each August, at the end of the season at the park, Slovenians gather for the Vinska Trgatav, or Wine Harvest.

Prior to the celebrations, John and some friends prepare the pavilion by draping greens on the overhanging roof and attaching pieces of candy and bunches of grapes to the greens. They construct a small "jail" out of tree branches. As the festivities continue throughout the day, including the consumption of traditional foods and beer and the playing of Slovenian polka and waltz music by the Milwaukee group "Echoes of Slovenia," several pre-appointed "police" officers arrest people who try to steal the candy and grapes from the roof. The perpetrators are thrown into the jail and a "bail" must be paid before they're released. The game is a great favorite among the children, but it's also a form of entertainment and merriment among the older members of the community. For Milwaukee's Slovenians, the activities recreate a rural festival long displaced in their new home. The Vinska Trgatav is a nostalgic reenactment, but the activities that go on each summer at Trgatav Park keep together a community that has seen its young members move away. Practically all of the picnickers at the Vinska Trgatav are over 60 or are young grandchildren. The generation in between is conspicuously absent.

ACTIVE ETHNICITY

Albert Larsen was born in Kenosha into a Danish family. His father came to America to work as a glass blower, a profession in which he apprenticed in Denmark. The job never materialized, so he settled in Kenosha where he had relatives. Albert learned the art of heart basketry from his father and mother. A traditional art form, the woven paper baskets are used to decorate Christmas trees. The baskets are filled with candy and sent home with holiday visitors. The Danish colors of red and white are used in the intricate baskets.

Albert Larsen is part of a strong Danish community that thrived in Kenosha. Danes first arrived in the area around 1850.

Drawn to the landscape and the waterfront, they prospered in the manufacturing and industrial fields in the area, and eventually they created an entire neighborhood of Danish-owned and Danish-run shops, bakeries, businesses and clubs.

Inga Hermansen and her husband Axel came to Racine's Danish community in 1955 because they had relatives there. By that time the Danish community was a vital force in the cultural life of Racine. Danish Brotherhoods and Sisterhoods, lodges with business and social missions beyond entertainment, made the transition for new immigrants easier.

The Larsens and the Hermansens belong to a group of people who once lived in close proximity to each other. Danish-owned bakeries, hardware stores and groceries functioned as the center of social order in the city, but the core of the community has slowly dispersed and the Danes moved to other parts of Racine and Kenosha and the Milwaukee area. The fraternal lodges and clubs help maintain the community by having members work together on issues that directly affect the Danish community in America. National organizations come together with local groups to develop policy on such issues as insurance and retirement pensions. They take up community issues, like the building of a Danish retirement home in Racine, and they hold craft fairs and holiday celebrations to raise money for their organization and for charitable causes.

Members of the organizations, like Albert Larsen, have taken on the cause of keeping Danish traditions alive and teaching them to other people. Besides his involvement in the Brotherhood, he teaches his basket making skills to people through museum demonstrations and holiday folk festivals. Retirement has become an almost full time job; he divides his time between Danish Brotherhood meetings and business, and

the demonstrations of traditional Danish art and folklife. Inga Hermansen finds her skills at Danish cross-stitch are important to the traditional life of the community. She helps make the costumes worn during the Danish conventions and the aprons worn at the Danish O&H Bakery. At home, Inga works at maintaining the traditions that make their Christmas celebrations in this country as Danish as possible.

SHARING TRADITIONS

Within urban areas like Kenosha or Milwaukee, ethnic groups form neighborhoods and open businesses that cater to a select clientele. While their services are directly connected to one ethnic group, the influences of that group's culture and traditions directly effect the cultures and traditions of other groups. For those reasons, it's no wonder that Gloriosso's grocery on Brady Street in Milwaukee or Groppi's in Bayview find their clientele extends beyond the Italian community.

In Sheboygan and Milwaukee, Asian import and grocery stores sell items that are essential to the foodways and lifestyles of the members of the Hmong community. Restaurants serve ethnic foods to members of the community, but those restaurants often choose to attract a more general group of people who enjoy eating ethnic foods as well. El Rey's on South Sixteenth Street in Milwaukee has grown from a small grocery store to a tortilla factory, bakery, butcher shop and grocery store that specializes in Hispanic products. Customers can purchase botanica items like candles and oils that ensure positive spirituality for the home and body. The store's owners respond to the needs of the community that supports them. At the same time, non-Hispanics at El Rey eat in the cafe and shop for exotic peppers and spices.

CITY LIFE

What cities do so well is teach us about each other. The close proximity of living space, the diversity of languages heard on busses and in grocery stores, the architecture of church steeples and storefronts, and the festivals that celebrate the artistic nature of ethnicity influence not only the way we think of others, but how we perceive the world around us and how we define ourselves as neighbors. Urban life breaks down stereotypes as easily as it forms them. For Wisconsin's ethnic communities, the urban areas along the shores of Lake Michigan provide a sense of connectedness and the opportunity to become Americans while maintaining the distinct ethnic traditions that give them their uniqueness. The ability to be who we are dictates the quality of life we have and the lives we create for our children. Cities provide us with extended families that help us to constantly reaffirm our ethnic identities.

FOLK ARTISTS

FOLK ARTS ALONG WISCONSIN'S ETHNIC SETTLEMENT TRAIL

Unlike Wisconsin's Czechs, who settled here in the mid- to late-nineteenth century, the state's Slovaks were part of the great wave of European immigrants who arrived in this country closer to the turn of the century. While the Czechs found an abundance of good farmland available upon their arrival, little good agricultural land remained when the Slovaks reached the state. Consequently, many Slovak immigrants from rural agrarian villages found themselves settling in urban areas where men took jobs in the factories and women served as domestics.

In Milwaukee, the Slovaks settled in ethnic neighborhoods hard by the industrial plants of the Menomonee River Valley. Sidonka Wadina Lee was born in 1947 and raised in one of these working class neighborhoods by second-generation Slovak-American parents. Both of her grandmothers, Johanna Biksadsky and Anna Wadina, having immigrated from Slovakia and put down roots in the area, still lived nearby.

When Sidonka was only two, she began visiting her Grandmother Biksadsky regularly, walking down the block to help with the baking and the making of Slovak dumplings. Unlike some of her immigrant neighbors, Johanna Biksadsky was not prepared to abandon her Slovak heritage in exchange for an homogenized American identity. She continued to practice such traditional arts as cookery, egg decoration, and fancy embroidery in her home. She also joined the International Institute, under whose sponsorship she frequently presented programs on Slovak culture in area schools. Biksadsky often took Sidonka with her to these presentations. As the eldest grandchild and the one who demonstrated the strongest interest in her cultural heritage, she soon became Johanna's protegee, helping with demonstrations, dancing in the International Institute's Holiday Folk Fair, and returning with her in 1964 to visit relatives in Czechoslovakia.

Today, Sidonka Wadina Lee continues to practice three forms of Slovak folk art: egg decoration, painting on woodenware, and–her specialty–straw work. Sidonka learned to paint Easter eggs from Johanna Biksadsky at an early age. However, she did not become acquainted with straw work until her visit to Czechoslovakia as a teenager. With the help of her grandmother who had practiced the art form as a youngster, Sidonka disassembled and reassembled wheat weavings given to her by a cousin in Europe and neighbors in Milwaukee in order to learn how to create the traditional house blessings and harvest crosses. Sidonka Wadina Lee has not been satisfied simply to reproduce those forms which were handed down to her, however. Like any accomplished artist, she has not only mastered

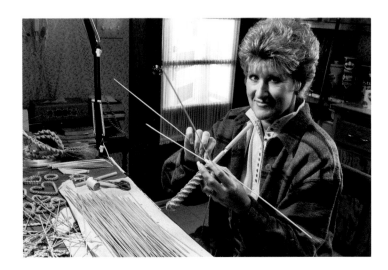

SIDONKA WADINA LEE
LYONS, WISCONSIN

the skills and techniques of her predecessors, but has also attempted to bring new life to the tradition through her own creative experimentation. In recent years, Sidonka has added such forms as swans to her repertoire of straw work. In addition, some sixteen years ago, Sidonka began doing a collectors series of handpainted wooden plates decorated with representations of customs of Slovakia.

Through her dedication to tradition, her exceptional artistry, and her exciting creativity, Sidonka Wadina Lee has accomplished the mission her Grandmother Biksadsky began so many years ago–preserving the folk cultural heritage of the Slovak community in Wisconsin and sharing it with others.

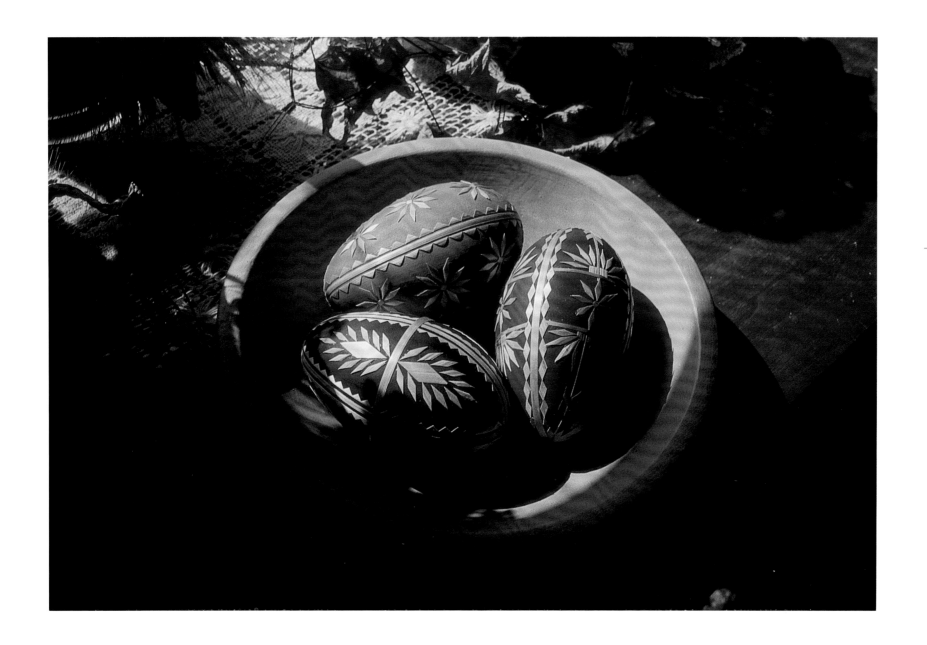

■ EASTER EGGS DECORATED WITH CUT STRAW BY SIDONKA WADINA LEE.

In Denmark, the heart is a national symbol. Typically rendered in the red and white of the Danish flag, it appears as a decorative motif on regional costumes, on handmade table runners and bell pulls, and on traditional Christmas decorations. Not surprisingly, this pervasive symbol of Danish ethnic identity continues to play an important role in the lives of Danish-Americans living in Wisconsin. Indeed, two of them—Albert Larsen of Bayview and Inga Hermansen of Racine—have combined the skill of their hands with the love in their hearts to share this symbol not only with their countrymen, but with friends and neighbors as well.

Albert Larsen learned the tradition of making heart baskets from his father, who settled in Kenosha's already established Danish community in 1909 after coming to America from Olberg, in Jutland, Denmark. He taught Albert how the woven paper baskets were used to decorate the Christmas tree and sometimes displayed in household windows during the holiday season. Albert also learned that it was an old Danish custom to take the empty baskets from the tree, fill them with candy, and give them to visitors and guests during the holiday season to take home with them. While other Scandinavian groups made heart-shaped baskets in their traditional colors, Albert's father taught him that only the Danes made theirs of red and white paper.

A stickler for detail and precision like his father, Albert Larsen continues to make Danish heart baskets in essentially the same manner he was taught. Using only a pencil and scissors, Larsen transfers patterns from detailed measurements or cardboard templates to one white and one red sheet of glossy wrapping paper. Slits are then cut part way up the folded strips of paper, and the resulting loops or "members" are woven through one another. Once the body of the basket is completed, a handle is added. While Albert once affixed the handles with paste, he now prefers Scotch tape for its appearance and durability.

Just as Albert Larsen learned to make heart baskets from his father, Inga Hermansen of Racine learned traditional counted cross-stitch embroidery from her mother. As a child in Denmark, Inga watched her mother, a seamstress by trade, making various decorative items for family and friends. Inga was also exposed to needlework in school, where she and other Danish girls began doing cross-stitch at the age of seven.

In 1955, Inga Hermansen left Copenhagen with her husband and three daughters and followed a path other Danes had trod for over one hundred years. They settled in Racine where her husband Axel's aunt and

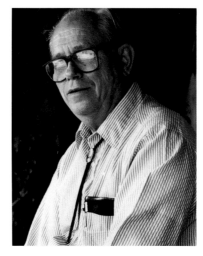
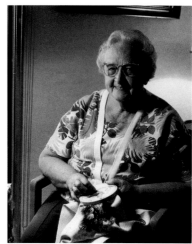

ALBERT LARSEN
and INGA HERMANSEN

BAYVIEW and RACINE, WISCONSIN

uncle lived and where there was a small Danish community. Axel, a trained engineer, found work with the Oster Manufacturing Company. Inga turned her sewing skills to work in a bridal shop and in her own drapery business.

Since coming to Wisconsin, Inga has continued to create the elaborate and intricate counted cross-stitch designs she first learned as a girl in Denmark. Working ten to twelve hours per day, Inga still fashions table runners, bell pulls, and dresser scarves adorned with national symbols and a variety of regional motifs. She uses only materials obtained from Denmark to create the traditional designs taken from color-coded, printed patterns which have been passed down through the years. While she respects the integrity of the old-fashioned patterns, Inga feels free to change the colors used in a particular scheme or to combine segments of different patterns. Through her personal commitment and creativity—and through her patient instruction of two of her daughters and four of her granddaughters in the tradition—Inga Hermansen has assured the continuation of Danish needlework in Wisconsin for years to come.

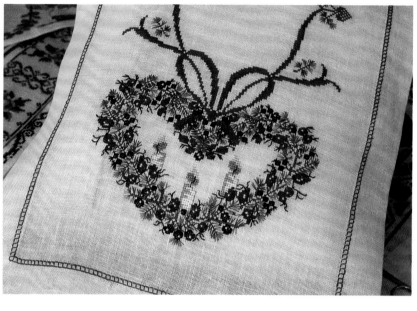

■ WOVEN PAPER CHRISTMAS BASKETS IN THE SHAPE OF HEARTS BY ALBERT LARSEN.

■ TABLE RUNNER DECORATED WITH A CROSS-STITCHED HEART MOTIF BY INGA HERMANSEN.

John Bambic was born in the Slovenian region of Yugoslavia in 1922. He was raised on a farm, and as a boy he assisted a neighbor who ran a blacksmith shop. As a young man, Bambic worked as a butcher for a number of years.

For five years following World War II, John Bambic was held in a displaced persons camp in Austria. In 1950, he immigrated to the United States, following a friend who had come to Milwaukee at an earlier date. Bambic and his wife settled in the old Slovenian neighborhood on the southwest side of the community, and he found work at the Pfister Vogel Tannery. Bambic was employed by Pfister Vogel for more than thirty years, until his retirement in the mid-1980s.

Throughout his working life, John Bambic was an active member of the Slovenian Lodge and a regular participant in such ethnic activities as the International Institute's Holiday Folk Fair. In 1962, Bambic and a group of fellow Slovenians purchased property on Wind Lake in Racine County as a summer camp. Equipped with a clubhouse and cottages, the camp was to be used for vacations, picnics, and group outings.

While visiting the Slovenian camp one weekend shortly before his retirement, John Bambic came across an old linden tree that had fallen down. The tree reminded him of Old World carvings which were made from linden wood, and this recollection prompted him to attempt some carvings of his own. He started out making wind-powered noisemakers like those he remembered being used to scare the crows away from the vineyards in Slovenia. Later, he turned his hand to fashioning more elaborate ornamental whirligigs.

Since his retirement from Pfister Vogel, Bambic has devoted a good deal of his time and imagination to making whirligigs. While he prefers to walk and garden in the summertime, Bambic works on his wind toys almost every day throughout the winter. Many of the whirligigs he creates are autobiographical. For example, he has fashioned wind machines depicting both the blacksmith shop and the butcher shop where he worked in Slovenia, as well as scenes showing two men drinking and eating bread and a woman cooking. Bambic also creates a wide variety of other types of whirligigs, the designs for which sometimes come to him at night when he cannot sleep. Seasonal subjects–from Santa Claus in various manifestations to witches riding on brooms–also find a place in Bambic's repertoire.

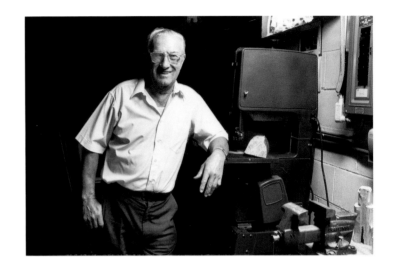

JOHN BAMBIC
MILWAUKEE, WISCONSIN

Each of Bambic's more elaborate whirligigs takes roughly a week to carve, assemble and paint. Consequently, he sells most of his pieces for about $200, approximately the amount he used to make for a week's work in the shop. Bambic's whirligigs–especially his more autobiographical works–are very popular among his fellow Slovenians who value the moving images of their homeland which are captured in these traditional art forms.

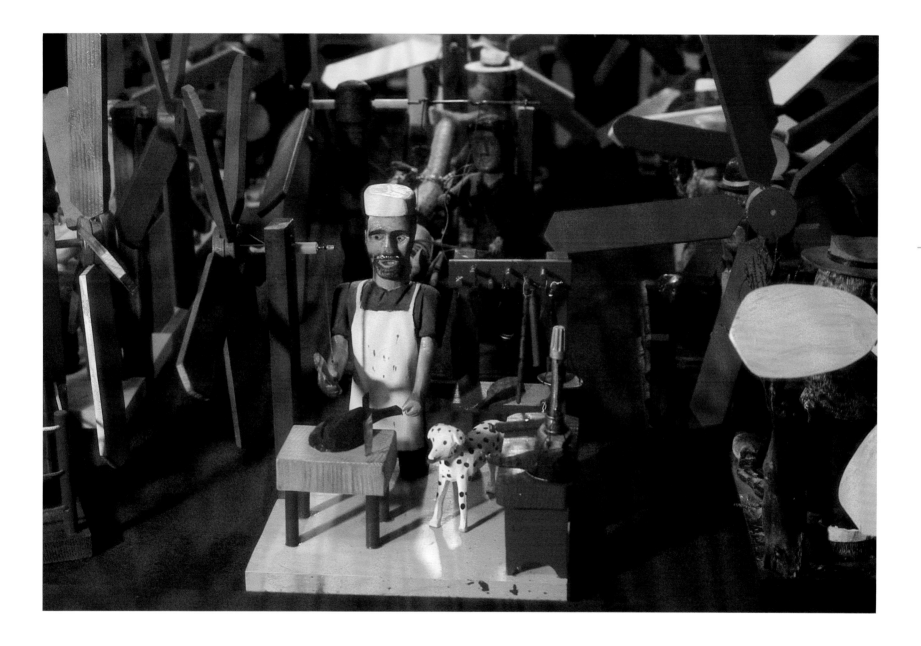

■ BUTCHER SHOP WHIRLIGIG BY JOHN BAMBIC.

Allie Crumble was born in 1911 in Newton County, Mississippi, and raised in Sardis. In 1944 she moved to Milwaukee with her second husband who had relatives in the city. He found work first at Milwaukee Boiler and then at A.O. Smith, but later went into business on his own as a carpenter. Allie never worked outside the home, choosing instead to be a housewife and to raise ten children. Her husband passed away in 1983, and since that time Allie's mother, Minnie Lofton, and, more recently, her daughter, Ivory Pitchford, have shared her home.

Allie Crumble first learned to piece quilts from her mother at the age of seven. Allie's mother made paper patterns for her daughter to follow in cutting the fabric squares for her first four-patch quilt top. She also supervised her daughter's work very closely, insisting that she tear out and redo any stitches not properly executed. Though there were many times when Allie would have preferred to go outside and play with the other children, she worked hard on her piecing for some two years. Then, at about the age of nine or ten, Allie was allowed to move on from merely "piecing" quilts to actually "quilting," sewing the quilt top to the batting and backing with a variety of decorative stitches. By the time she was twelve, Allie was sufficiently accomplished to help her mother with her quilts.

Allie Crumble has continued quilting on a regular basis throughout her entire life. Prior to her husband's death ten years ago, Crumble produced roughly one quilt per month. Each quilt required two weeks to piece and two weeks to quilt, and she worked on her quilting an average of six hours per day, six days per week. Since her husband's death, Allie has produced only a small number of quilts for her own use, for her grandchildren, and for sale. She refuses to make quilts to order, preferring instead to sew favorite traditional patterns or to create new ones of her own. Among her favorite patterns are those she calls "eight-point star," "sawtooth," "Aunt Sooky," "broken dishes," "spider web," "teacup" and "card trick." On some, she makes use of the string quilting technique characteristic of many African-American quilt makers.

Just as Allie Crumble learned to quilt from her mother many years ago in Mississippi, so too did Allie's daughter, Ivory Pitchford, learn the craft from her. Born in Sardis, Mississippi, in 1930, Ivory moved to Milwaukee with her parents at the age of thirteen. After attending school in Milwaukee, she married in 1949 and moved to Los Angeles three years later. Ivory lived in California for thirty years, working at Northrop Aircraft and at the Beverly Hills Hotel. In the early 1980s, she moved to Mississippi

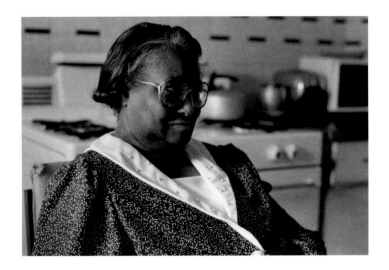

ALLIE M. CRUMBLE and IVORY PITCHFORD

MILWAUKEE, WISCONSIN

with her husband, a minister. After his death in 1987, she moved back to Milwaukee to live with her mother.

Ivory Pitchford's first quilt was a string quilt that her mother taught her to make. She started it at about the age of 16, constructing blocks about the size of a napkin from "strings" of fabric. She quilted it herself, in "shares" or sections, just as her mother did. Over the years, Pitchford has made quite a few string quilts, including one for each of her five boys. While she is rather pessimistic about the next generation carrying on the quilting tradition in the manner she has, Ivory would like to start a quilting club in order to share her knowledge with others. And, just as her mother started her out on a string quilt, she would use the same pattern to introduce her students to the African-American quilting tradition.

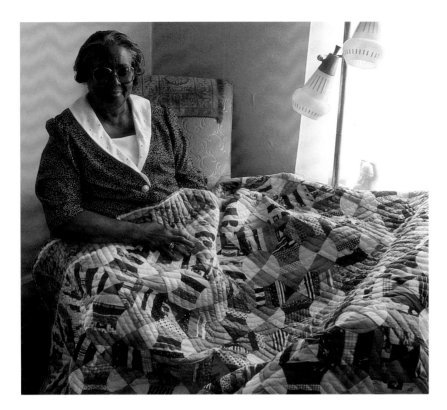

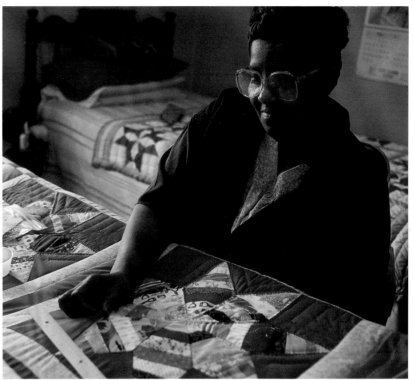

■ ALLIE CRUMBLE DISPLAYS A "SNOWBALL" QUILT.

■ IVORY PITCHFORD STITCHES A STRING STAR QUILT.

The Hispanic communities in metropolitan Milwaukee have grown large over the past sixty years, and the populations of Hispanic neighborhoods on the near south side and in suburban Waukesha continue to increase. Mexicanos and Tejanos were among the first Hispanic settlers in the region, coming to Milwaukee as early as the 1930s. Similarly, Puerto Ricans have made their way to Milwaukee, sometimes by way of New York, since the 1950s. A small number of immigrants from Central and South America have also found their way to the area during the last decade.

Within these Spanish-speaking ethnic groups, a variety of folk arts and crafts continue to thrive and to evolve, actively practiced by a number of individual artists. One of the most sought-after traditional artists in the metropolitan Milwaukee Mexican community is Berta Mendez. Born in 1934 in El Paso, Berta grew up surrounded by pinatas, paper flowers and other material manifestations of Texas-Mexican culture. Her mother, Berta Ramirez, made paper flowers, and she followed suit, making and exchanging the brightly colored flowers with a circle of girlfriends on birthdays and other special occasions. However, it was not until the early 1950s, when she married, moved to Milwaukee, and began to raise a family, that Berta Mendez became really active in paper artistry. No longer able to cross the border to Juarez to buy pinatas, she quickly realized that she would have to make them herself if they were to be a part of a child's birthday celebration. Soon Berta was not only making pinatas for her children's birthdays and for Christmas, but also for her children's school, for the Baptist church her husband pastored, and by the mid-1970s for community events celebrating ethnic heritage.

In pursuing her folk art form, Berta Mendez has continued to make pinatas in traditional shapes like the star. However, she has also fashioned a number of innovative new designs, including pinatas in the shape of birds, snowmen, hearts, and even Santa Claus and his elves. For Waukesha's Latino Days, Mendez created a series of giant pinatas symbolic of Mexican-American culture. These included pinatas in the shape of a sombrero, a taco, a jalopena pepper, and a guitar. Berta Mendez has also passed along the tradition of paper artistry to her nine children. The fact that most of them made pinatas for her and her husband on the occasion of their fortieth wedding anniversary indicates quite clearly how successful she has been in passing along her heritage to the next generation.

Another active folk artist from Milwaukee's Hispanic community is Manuel Reyes, a native of Utuado, Puerto Rico. Born in 1934, Reyes was one of fourteen children in a family of agricultural workers in the forested Puerto Rican highlands. He grew up working in the fields, cutting sugar

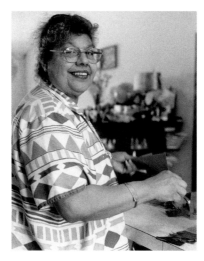 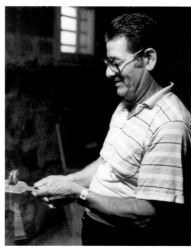

BERTA MENDEZ and MANUEL REYES

WAUKESHA and MILWAUKEE, WISCONSIN

cane, and felling trees for charcoal. Reyes' family also raised roosters which were sold to a middleman who trained the birds for cockfights. In 1968, Manuel Reyes was disabled in a factory accident in Puerto Rico. Two of his older brothers had found work in Milwaukee, and in 1981 Reyes moved to the city with his wife, three sons, and a daughter.

Although Manuel Reyes did not do any woodcarving in Puerto Rico, he knew the noted carver Emilio Rosado, also from Utuado, whose colorful roosters have won national acclaim. Soon after coming to Wisconsin, Reyes took up the craft as a way of making a little money from work he could do at home. Using knives, chisels and sandpaper, he carves a variety of figures from scrap wood and, occasionally, even from soap. All of his figures are then painted in naturalistic hues. Among these figures are roosters, like those carved by Rosado, as well as a number of symbols of his Puerto Rican identity. Through the creation of these carvings, just as through his composition of poems in traditional prosodic form, Manuel Reyes maintains his association with his homeland while at the same time sharing its culture with family, friends, and his new neighbors in southeastern Wisconsin.

36

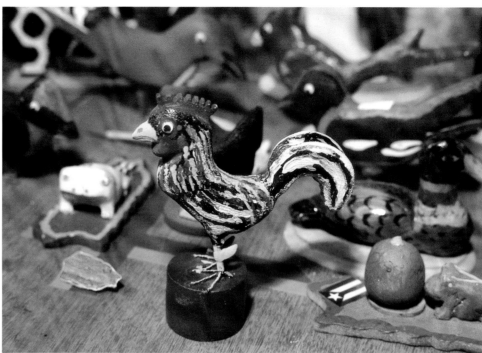

■ HEART PINATA BY BERTA MENDEZ.

■ CARVED WOODEN ROOSTER BY MANUEL REYES.

Elizabeth Keosian was born on September 25, 1909, in Adana, Turkey–then Cilician Armenia. When she was only three months old, her father, grandfather and other male relatives were "purged" by the Turks for refusing to deny Christianity. Shortly thereafter, Elizabeth's mother lost her eyesight, possibly as a result of the emotional stress. Elizabeth remained in Turkey with her mother until the age of ten, at which time they fled to a refugee camp in Lebanon. After nine years in Beirut, she came to Milwaukee in 1929 as the "mail-order bride" of a friend of her sister, an Armenian who had immigrated to the United States in 1912.

Elizabeth Keosian began learning Armenian lace-making from her older sister at about the age of five or six. She started by fashioning lace borders for handkerchiefs and later graduated to making doilies. While living in Lebanon, Elizabeth learned to embroider and to do "Aintab" drawn work on a frame. By the time she was nineteen years old, just before she was to marry, she had prepared an entire hope chest full of needle-lace doilies and trims for wedding garments and underclothes, including a square yoke for a nightgown, trim for each leg of a pair of pantaloons, and a lined drawstring purse.

Since coming to the United States, Elizabeth Keosian has continued to practice her traditional needlework. Rather than preparing intricate articles of clothing as she had in Turkey and Lebanon, however, Elizabeth has turned her lace-making skills to decorative items for her home and to gifts for members of her family. Using the same needle she has employed for thirty-eight years and DMC thread which she prizes for its delicacy and durability, Keosian fashions dresser scarves and doilies of Armenian needle lace. In addition, she continues to practice the embroidery she learned in Lebanon, decorating pillow covers and other items. Utilizing crocheting skills she acquired after arriving in this country, Keosian has also created a variety of large pieces–tablecloths, chair coverings, and bedspreads among them–which adorn her westside Milwaukee home.

Although her eyesight is not as good as it once was, at the age of eighty-four Keosian still makes gifts of her needlework for her many nieces and grandnieces. While she creates simpler pieces for birthdays and holidays, she reserves her more intricate work with its complicated stitches and fine thread for such special occasions as weddings. A member of St. Hagop's Church in Racine, Keosian also remains an active participant in the southeastern Wisconsin Armenian community. For more than thirty-five years, she has participated in the International Institute's Holiday Folk Fair in Milwaukee, where she continues to share with others the intricately interwoven threads of her needlework, her heritage, and her life.

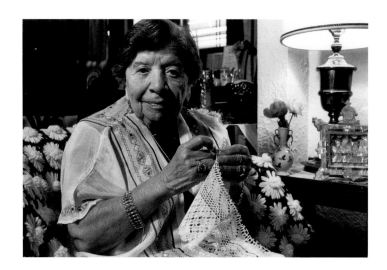

ELIZABETH KEOSIAN

MILWAUKEE, WISCONSIN

■ ARMENIAN NEEDLE LACE DOILY ATOP ELIZABETH KEOSIAN'S TELEVISION.

"Bernie" Jendrzejczak is a third-generation Polish-American, born and raised in Milwaukee. Her mother and father were also born in Milwaukee of parents who had immigrated from Poznan and Bydgoszcz, respectively. Like many other Polish-Americans, the Jendrzejczaks have always observed a variety of traditional holiday customs in their home. Each Easter they decorate eggs with designs applied with the old-fashioned wax-resist method. The Jendrzejczaks also follow Polish custom at Christmastime, celebrating the birth of Christ with a *Wigilia,* or "Vigil," observance on Christmas Eve.

Taught by her family to value the customs of her ethnic community, Bernie Jendrzejczak joined Polanki, a Polish women's cultural club, after she graduated from high school in the early 1970s. At the time she became a member of the organization, a number of the older women found themselves unable to continue to teach and demonstrate Polish folk arts. As a result, Bernie became actively involved with this aspect of Polanki's cultural conservation program.

Bernie Jendrzejczak drew upon a variety of sources as she began to learn *wycinanki,* or Polish paper cutting. She gleaned some things from the senior members of Polanki, others from Ryszarda Klim, an artist recognized for her paper cutting by the Milwaukee Polish community, and still others from Mrs. Wladsyslawa Muras, a professional folk artist from Poland who visited Milwaukee on several occasions. Bernie also learned a good deal about *wycinanki* on her own, disassembling paper cuts sent by friends and relatives in Poland to see how they were made, and reading books and pamphlets on the subject.

Eventually Bernie Jendrzejczak mastered not only the well-known styles of Polish paper cutting from the regions of Kurpie and Lowicz, but also some less familiar forms like those from Opoczno. Bernie's *gwiazdy,* or "stars," exemplify one style of paper cutting practiced in Kurpie. Bernie also fashions *leluje,* another style of paper cut from the Kurpie region which takes the form of a tree of life or an altarpiece. In addition to the styles from Kurpie, two designs from the Lowicz region are part of Bernie's repertoire: circular "wheels" consisting of dark backgrounds overlaid with layers of brightly colored paper flowers, roosters or other animals; and *kodry* which customarily consist of overall floral patterns or scenes from domestic life. Bernie also fashions simpler Opoczno paper cuts in the form of birds, as well as *fajerke* which resemble stencils or stained glass when backed with colored paper.

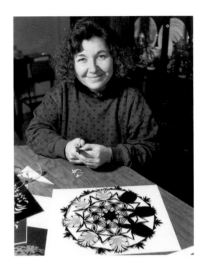

"BERNIE" JENDRZEJCZAK

HALES CORNERS, WISCONSIN

While Bernie Jendrzejczak is thoroughly acquainted with the materials and usages of *wycinanki* in Poland, she has introduced some changes in fashioning her own work. Instead of the flimsier paper used in Europe, Bernie makes use of wrapping paper or origami paper in her paper cuts. Similarly, she has substituted Elmer's Glue for the paste of boiled flour and water used in Poland. With regard to usage, Bernie still makes paper cuttings for such traditional purposes as decorating eggs as Christmas ornaments. However, she also has adapted her designs for use on greeting cards and decoupage plaques.

Now a research technologist at the Medical College of Wisconsin and president of Polanki, Bernie Jendrzejczak continues to make *wycinanki* and to teach the art form to school groups, Girl Scout Troops, and interested adults. She also has been a regular participant in the International Institute's Holiday Folk Fair over the years and has demonstrated at the Milwaukee Public Museum, the Boerner Botanical Gardens, and at Cardinal Stritch College.

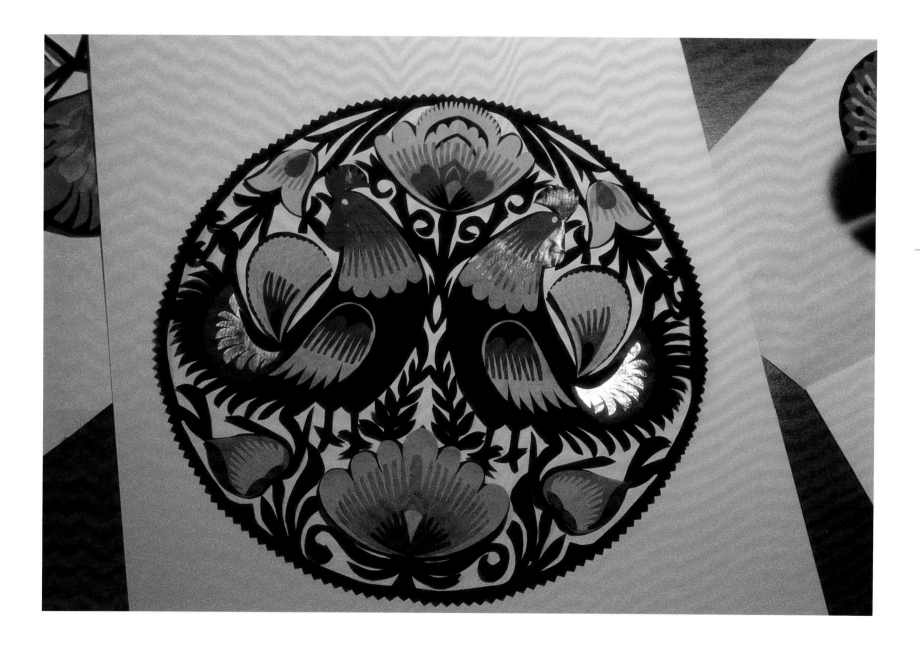

■ *WYCINANKI* IN THE STYLE OF THE LOWICZ REGION FROM THE COLLECTION OF BERNIE JENDRZEJCZAK.

Freistadt was founded in 1839 by a group of twenty Pomeranian families who came to this country to find freedom from the religious oppression of their homeland. The settlers established their own church, Trinity Lutheran, soon after their arrival. From the time Freistadt was founded to the present, music has played a significant role in the everyday life of the community. There were at various times a men's choir and a brass band affiliated with Trinity Lutheran Church, and the Freistadt Cornet Band was one of the better known turn-of-the-century *blaskapelle* in the area. Since 1942, however, the tradition of performing German music in Freistadt has been the primary responsibility of a single group, the Alte Kameraden Band.

The group got its start just over fifty years ago when eight or ten members of the Lindenwood 4H Club formed a band to perform for a play put on by the organization. This was a difficult time in Freistadt since the United States had just entered the war with Germany and Japan. To show their support for their country's effort and to demonstrate their own patriotism, the young 4H members called their group the Victory Band. Following their performance in conjunction with the play, the band was invited to perform at a number of weddings and anniversary celebrations over the next several years. In exchange for their performances, the Victory Band was occasionally offered a few dollars or given a free meal.

During the ensuing years, the band played every now and then, rehearsing only when there was an invitation to play. Each year they joined their fathers and other musicians from the congregation for the Trinity Lutheran Church Fourth of July Picnic. After marching in the parade–clad in their "uniforms" of black trousers, white shirts, red suspenders, black bow ties, and black bowler hats–the Victory Band and their elders played a concert using selections of German music from the church band's library.

The Victory Band retained its name and its red, white and black marching uniforms until 1966, when the group decided a somewhat more professional structure and a more recognizably "German" image was needed. In preparation for their appearance at the Germantown Lions Club's first Oktoberfest, the band decided to change its name to the Freistadt Alte Kameraden Band, adopting the title of their signature parade march. The members also decided to purchase lederhosen–since the Lions Club was ordering them anyway! Coupled with new black felt "Alpine style" hats with red piping and long pheasant feathers, the lederhosen gave the Alte Kameraden Band the new look they desired.

From the late 1960s on, the Freistadt Alte Kameraden Band achieved growing recognition. In 1969 the group was asked to perform for the

Trinity Lutheran Church Band, c. 1954.

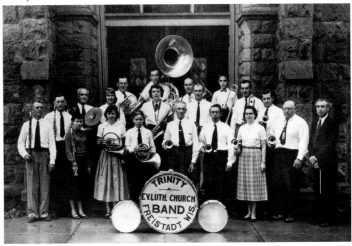

FREISTADT ALTE KAMERADEN BAND

FREISTADT, WISCONSIN

Drei Trachten Verein of Milwaukee, its first performance for a German organization in the area. For the occasion, the band members replaced their Alpine hats with new white-plumed Miesbacher hats, completing their transformation into a Bavarian band. In 1972 the Alte Kameraden accompanied the dancers from the featured Bavarian ethnic group at the International Institute's Holiday Folk Fair in Milwaukee. And, in 1976, the Alte Kameraden Band was featured at the Smithsonian Institution's Festival of American Folklife on the Mall in Washington D.C. Throughout the 1970s and 1980s, the Alte Kameraden also made three playing tours of Germany, five musical recordings and appeared on local radio as well as on network television.

The impressive history of the Alte Kameraden Band is, perhaps, best summarized in the words of Don Silldorff, a longtime member of the group who compiled its history for their Fiftieth Anniversary Program: *"The small group of friends who got together in 1942 to play for fun and 4H competition never dreamt of the things that would happen to them along the way, and least of all that they would still be a group fifty years later. They now strive for excellence and play for enjoyment and camaraderie."*

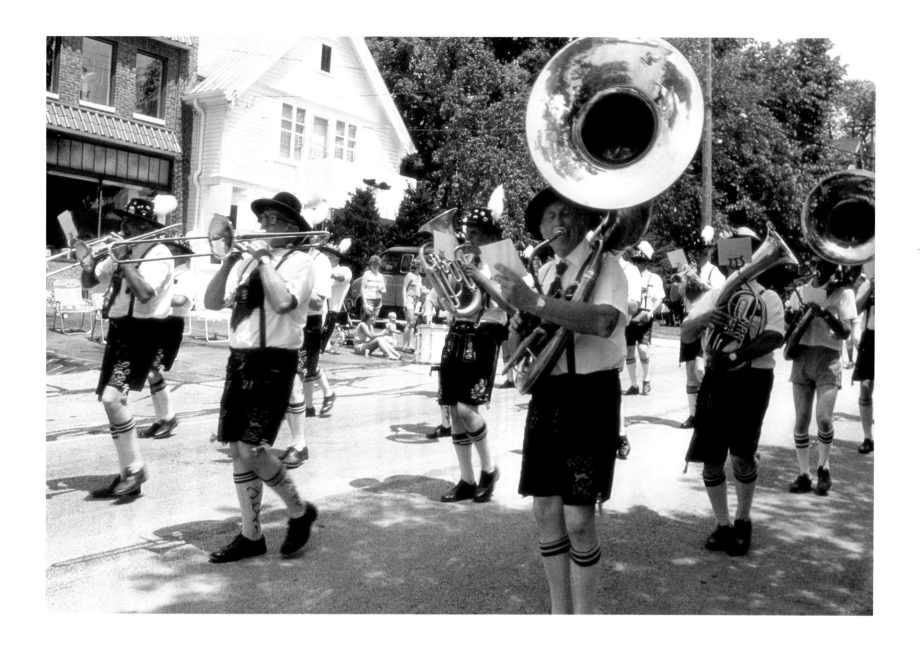

■ THE ALTE KAMERADEN BAND IN FREISTADT'S FOURTH OF JULY PARADE.

The Dutch or "Hollanders" who settled the Sheboygan County communities of Cedar Grove, Gibbsville, and Oostburg in the 1840s and 1850s brought with them the tools and techniques needed to make the traditional footwear of their European homeland, wooden shoes. In Wisconsin as in Holland, the shoes were worn primarily for farm work, especially barn chores and gardening, and were always removed before entering the house. Indeed, one local tradition has it that you could tell the number of dwellers in any given household by counting the pairs of shoes left outside the door.

At the beginning of this century, there were approximately a dozen wooden shoemakers still active in the three Dutch communities. However, their numbers declined steadily as cheaper footwear became available and as the tastes of subsequent generations changed. In the mid-1940s, William Ros of Gibbsville was profiled in Fred Holmes' book *Old World Wisconsin* as the only remaining wooden shoemaker in the area. Later sources suggest that another local craftsman, William Klompenhouwer of Oostburg, was more deserving of the title "last wooden shoemaker." Both Klompenhouwer's father and grandfather had made wooden shoes, and William learned the craft from his father. His "Klomp Shop," with its homemade wooden windmill out front, stood on the north side of Oostburg's village park and served customers until the late 1950s or early 1960s.

After William Klompenhouwer gave up making wooden shoes, the Cedar Grove community frequently brought Fred Oldemulders of Holland, Michigan, to demonstrate the craft at its "Holland Days" celebration. Larry Wieberdink, a fifth generation Dutch-American who was raised in Cedar Grove, met Oldemulders at one of these events and was encouraged by the master to take up the craft. Wieberdink purchased a set of wooden shoemaking tools from a local man. He learned the basics from Oldemulders and eventually became proficient enough to demonstrate the use of the tools for local nursing homes and community groups. Unfortunately, a serious illness in his family forced Larry Wieberdink to turn more of his attention to his electrical business, and his wooden shoemaking tools have been packed away since about 1980.

Another local man, Bob Siegel, also learned to make wooden shoes from Fred Oldemulders. Although of predominantly German background himself, Siegel married a second generation Dutch-American woman from Pella, Iowa, a largely Dutch community. The couple frequently traveled to Pella to visit Mrs. Siegel's family, and there Bob became acquainted with a shoemaker named Willem Jansen. Siegel was allowed to film Jansen's shoemaking techniques, but the master was not much inclined to pass along to

Wooden shoemakers William Ros of Gibbsville and William Klompenhouwer of Oostburg.

LARRY WIEBERDINK and ROBERT SIEGEL, JR.

CEDAR GROVE AND MEQUON, WISCONSIN

him any of the tricks of the trade. As a result, Siegel traveled to Holland, Michigan, where Fred Oldemulders gave him a number of lessons in shoemaking and arranged for him to travel to Europe during the 1970s to study with a dozen master craftsmen. Since that time, Siegel has continued to make wooden shoes in either an outdoor shed or the garage attached to his Mequon home. He frequently demonstrates his craft for local historical societies and at ethnic festivals throughout the Midwest.

Although the tradition of wooden shoemaking is no longer actively practiced by any members of the Sheboygan County Dutch community, the wooden shoe remains an important symbol of ethnic identity for its members. Signs in the shape of wooden shoes greet visitors to the community and to many of its businesses. Decorated wooden shoes are displayed in homes throughout Cedar Grove, Oostburg, and Gibbsville. And the community's "Klompen Dancers" perform traditional ethnic dances in wooden shoes, albeit the mass-produced variety from the factory in Holland, Michigan. Rivaled only by the windmill and the tulip, the wooden shoe still symbolizes Dutch identity to both members of the local ethnic group and their neighbors and friends.

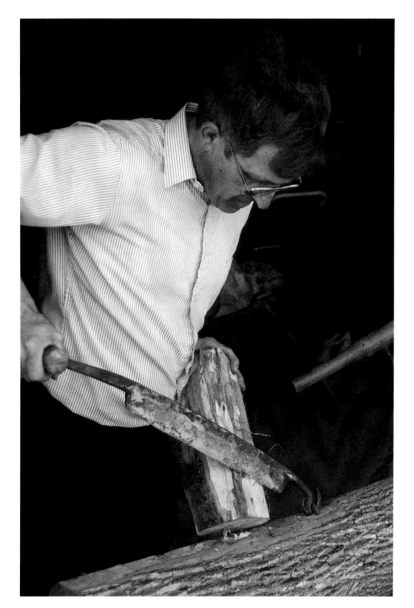

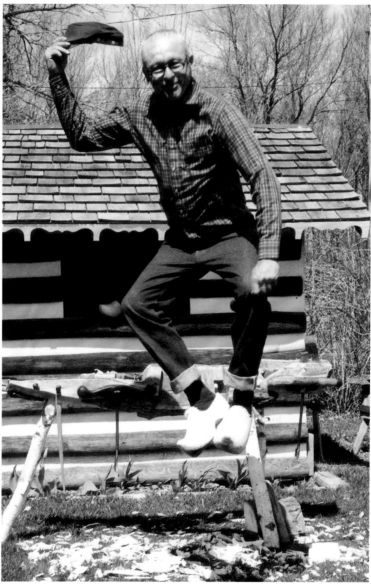

■ LARRY WIEBERDINK SHAPES A WOODEN SHOE.

■ BOB SIEGEL, JR. KICKS UP HIS HEALS IN A PAIR OF HIS OWN *KLOMPEN*.

Xao Yang Lee was born in an agricultural village in northern Laos in 1943. Her mother, Kai Yang Lee, began to teach her to sew and to create the intricate needlework characteristic of the White Hmong tribe when she was only six. With her mother's assistance, Xao Yang gradually mastered the art of decorating sashes, hats, bags and other articles of clothing with applique, reverse applique, cross-stitch and other traditional forms of embroidery. When she married and began to raise her own family, Xao Yang Lee applied her needlework skills to making her own clothing, as well as clothing for her husband and children. Like her mother before her, she worked on her embroidery by candlelight in the evening or during the day when chores were not pressing.

With the outbreak of the war in Southeast Asia in the 1960s, the long-established pattern of daily life among the Hmong was totally disrupted. Allies of the United States during the conflict, the Hmong who lived in the mountainous regions of northern Laos were forced to flee their homeland as the war came to a close and the Pathet Lao took control of the country. Many were killed, including Xao Yang Lee's husband. However, Xao Yang and her five children escaped across the Mekong River to a refugee camp in Thailand during the mid-1970s. There she and many other Hmong women were introduced to new ways to put their needlework skills to use while they awaited relocation. They learned how to employ traditional motifs and sewing techniques to fashion new items that would sell on the American market, and they learned how to modify their color schemes and select types of fabric better suited to their new clientele.

Xao Yang Lee came to the United States in 1979 after two years in a Thai refugee camp. She settled for a short time in California before moving to Wisconsin in April, 1980, to join her cousin. Now fully resettled in Sheboygan with her immediate family and many members of her extended family, Xao Yang Lee is employed as a second-shift factory worker in the local Wigwam Mills plant.

Although her circumstances have changed radically from the agrarian lifestyle she knew less than twenty years ago, Xao Yang Lee continues to utilize the traditional needlework skills learned from her mother in the mountains of Laos. She continues to make traditional clothing for members of her family. However, rather than creating clothing for daily use, she fashions baby carriers and funeral squares for use in life cycle rites, as well as costumes to be worn for special occasions such as the Sheboygan Fourth of July Parade and the Hmong New Year's celebration. Xao Yang

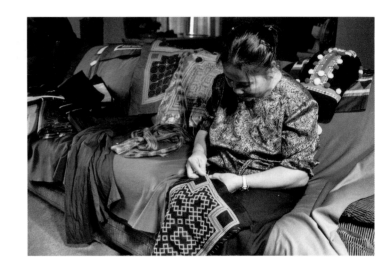

XAO YANG LEE

SHEBOYGAN, WISCONSIN

Lee also continues to fashion a wide range of inexpensive needlework items, much like those she learned to produce in the refugee camps, for sale to an American audience. Working in the mornings before she goes off to her factory job, Xao Yang makes necklaces, headbands, stuffed animals, Christmas ornaments, tree skirts, tissue box covers, "story cloth" wall hangings, and table runners which incorporate traditional motifs but are tailored to the needs of an American clientele. These she sells at weekend craft shows in Appleton, Beloit, Milwaukee, and other cities throughout Wisconsin.

Like many other aspects of Hmong traditional culture which have changed substantially during the two decades of transition following the war in Southeast Asia, Xao Yang Lee's needlework has undergone marked alterations in fabric, form and function. Yet, the motifs of Hmong needlework–whether applied to a traditional baby carrier or to a contemporary quilt–still provide a pattern for her life.

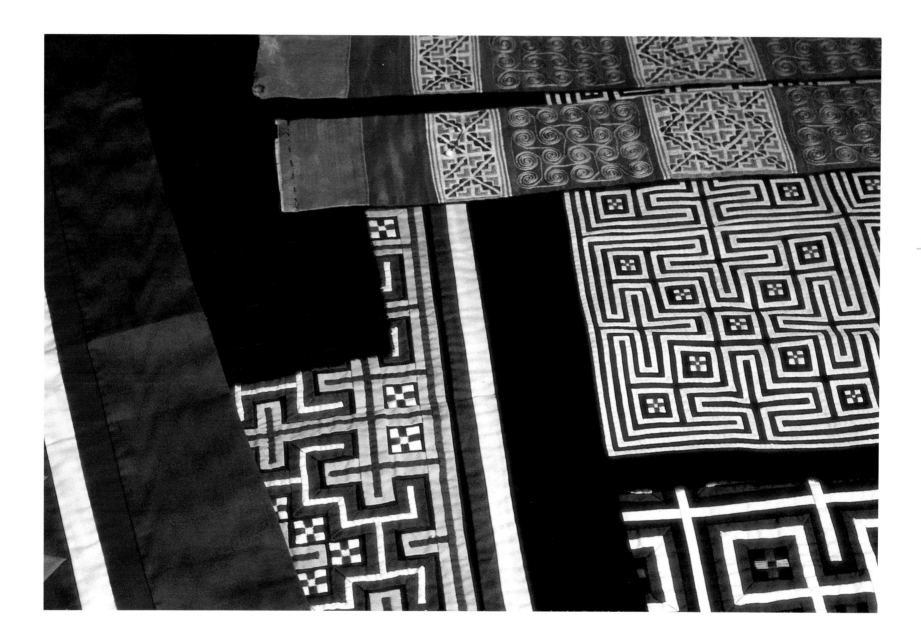

47

An Iroquoian people, the Oneida migrated to Wisconsin from New York State in the early nineteenth century. By the time of their migration, many of the Oneida had already been converted to Christianity by Episcopalian and, later, Methodist missionaries. In spite of these religious influences and a number of programs undertaken by the United States government to assimilate them, the Oneida people still retained many of their cultural traditions long after their move to Wisconsin.

Certain central elements of Oneida culture–for example, a variety of narratives, beliefs and practices regarding corn, their staple crop–persisted even into the first decades of the twentieth century. This was due, in large part, to the importance of corn to the Oneida as both sustenance and symbol. As Priscilla Manders put it: *"Corn was the most important thing that we planted because we made bread out of it, we made soup out of it. The chickens, the poultry, had food; the cows ate corn and they even ate the cornstalks–we had to give them that for winter food. So the corn really supplied food for everyone of us that was in the household."*

Corn harvesting and shucking remained communal tasks among the Oneida through the 1940s. Husks were sometimes used for bedding. Cornhusks were also used to make dolls, and the corndolls typically had traditional stories associated with them.

Priscilla Jordan Manders was born at Oneida in 1907. Her mother had been educated away from the reservation at boarding schools, but her father had resisted schooling and stayed at home. Priscilla was blind throughout much of her early childhood, and she grew up in the care of her paternal grandfather who lived with her family until she was six years old. Her grandfather spoke only Oneida, and from him Priscilla learned the language and many traditional stories about the corn and other plants. He also taught Priscilla to make cornhusk dolls, a task which she first had to accomplish entirely by feel as a result of her blindness.

Priscilla recovered her sight around the age of four and began attending school at seven or eight. She went to boarding school in Tomah in fourth grade, and later attended a Bureau of Indian Affairs boarding school in Pipestone, Minnesota. After leaving school, Priscilla moved to Milwaukee where she did housework and cared for children. Eventually, she married and had a family of her own. By the 1950s, Priscilla and her family returned to live in Oneida where she became a trained nurse and hospital worker.

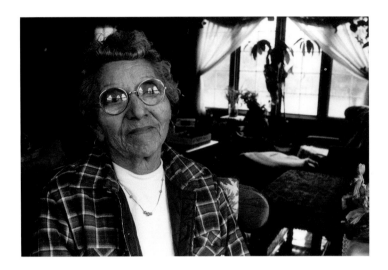

PRISCILLA MANDERS

ONEIDA, WISCONSIN

From the time of her childhood until sometime in the 1940s, Priscilla Manders made cornhusk dolls regularly. However, when she returned to work full time, she set aside the craft. Only in the late 1970s, when she began working for the Oneida tribe, did Priscilla return to dollmaking. To complement her teaching Oneida children about plants and medicines, Manders again began making dolls from white or "flint" corn which she had grown on the farm where she was raised. She makes her dolls entirely of cornhusks, which she dyes with raspberry juice or other natural materials to suggest clothing. At first she made upright dolls in the old style, but in the late 1980s she began to make them "doing something" to teach children about Oneida culture. Nowadays, most of Priscilla Manders' dolls are shaped to illustrate some type of traditional activity. Through this innovative elaboration upon the Oneida dollmaking tradition, the artist passes along to another generation not only her exceptional work but also a variety of elements of the Oneida cultural heritage.

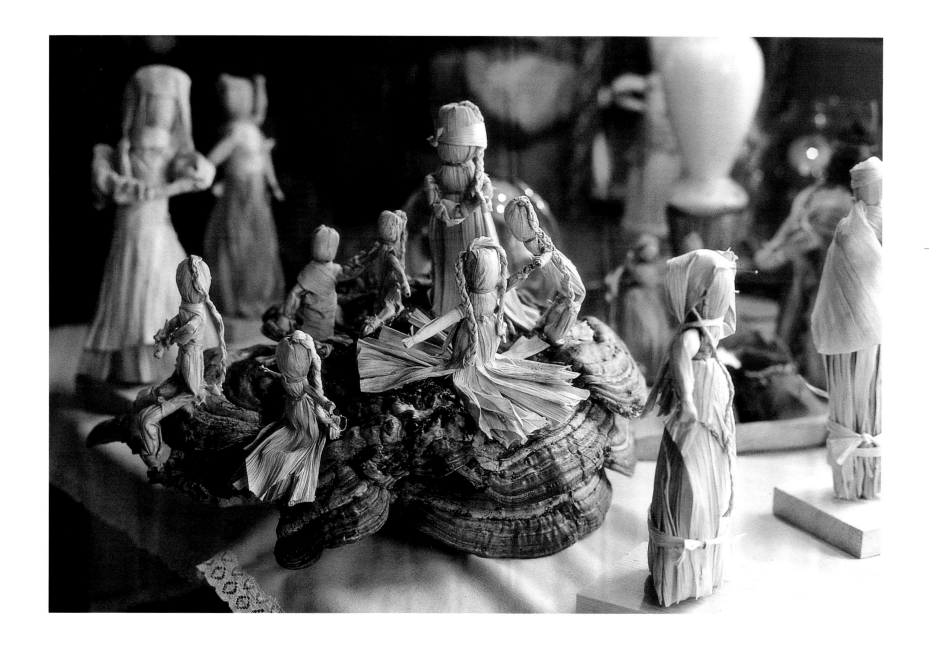

■ GROUPING OF CORNHUSK DOLLS BY PRISCILLA MANDERS.

During the mid-nineteenth century, Czechs or Bohemians settled in significant numbers throughout Manitowoc and Kewaunee Counties. A great many of the Czech settlers were farmers and most were Catholics. When they immigrated to Wisconsin, the Czechs brought with them a variety of ethnic traditions closely associated with the church and rural life. Among these were an extraordinary enthusiasm for brass band music, the making of many different types of baskets, and the use of goose feathers to fashion pastry brushes, dusters, feather pillows, and comforters. Many of these traditions, like the music of Bohemian polka bands, continue to thrive even to this day. Other traditions, like basketmaking, persist on a somewhat more limited basis, having survived over several generations within the Czech community but now dependent on neighbors of other ethnic heritages for their continuance.

Throughout the first half of this century, there were a number of active basketmakers in eastern Wisconsin's rural Czech settlements. Men like John Mleziva and Joe Swoboda made a variety of baskets suited to a number of different tasks. Most of their baskets were constructed of pounded black ash strips over oak or black ash frames, but some basket forms–such as bread baskets and bee skeps–were fashioned from twisted rye straw. One of the most popular types of basket made by these early craftsmen was the cattle feed basket, which was used by area farmers to haul chopped hay, silage, and other feed from the barn to their cattle. These large baskets–often two feet in diameter and three feet tall–were equipped with a single handle for carrying over one arm and with four small feet to keep the woven bottoms from rotting as a result of contact with the wet ground.

By the second half of the twentieth century, the number of Czech basketmakers had declined significantly. Only Joe Buresh and his neighbor Joe Shefcheck continued to make the various types of woven carry-alls once commonly available in the community. Joe Buresh was taught to make baskets by his grandfather, John Mleziva, and in order to "keep things going" Buresh taught his basketmaking techniques to several younger apprentices. One of these was John Arendt, a German-American neighbor in rural Luxemburg.

In the last few years, the number of active basketmakers has grown even smaller. Joe Shefcheck moved to Kewaunee in the late 1980s and gave up the craft when he left the farm. Joe Buresh passed away in 1991, leaving John Arendt as the only basketmaker in the area. Arendt was born in Luxemburg, Wisconsin, in 1942, the seventh of ten children in a German-American family. Around 1980, when Joe Buresh was beginning to make

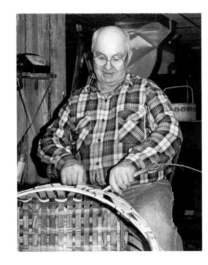

JOE BURESH
and JOHN ARENDT

LUXEMBURG, WISCONSIN

baskets in earnest once again after many years away from the craft, John Arendt came to work with him and to learn the process. Since that time John has made twenty-five or thirty baskets from local black ash. Although he knows how, John Arendt does not make the old cattle feed baskets any longer. Rather, he makes laundry baskets, picnic baskets, Easter baskets, and baskets for holding firewood.

The passage of the basketmaking tradition in Kewaunee County from members of the Czech community to a member of another ethnic group is not especially surprising. Czech-made baskets have been used by area farmers of various ethnic backgrounds for many years. Like these local farmers, John Arendt has long been familiar with the various types of baskets made and used in and around Luxemburg. His decision to continue making them may have come more from a sense of rural or occupational identification with the baskets than from a sense of ethnic identification. Whatever his motivation, however, John Arendt has performed a service to the community by continuing its basketmaking tradition into another generation.

■ BOHEMIAN CATTLE FEED BASKET BY JOE BURESH.

■ BLACK ASH FIREWOOD BASKET BY JOHN ARENDT.

Betty Piso Christenson was one of nine children raised by Stefan Piso and Justina (Stella) Kuzemka Piso on cutover land near Suring in Oconto County. Betty's parents were both born in the Ukraine. While in their teens, they migrated to McKees Rocks, Pennsylvania, where they met and married. Stefan's uncle had puchased logged-off acreage around Suring, so he did the same. Because they were the only Ukrainian families in the area, they would travel occasionally to Lublin to attend church and celebrate with a small community of countrymen.

Despite the family's relative isolation and the parents' desire to have their children become Americans, the Pisos continued to practice Ukrainian traditions associated with Orthodox Christianity and especially with religious holidays. Betty's father built and played fiddles, and on Saturday evenings he would play Old World tunes while the children danced around him. Her mother sang Ukrainian songs. At Easter, Stella Piso made simple, single-color eggs called *krizanki* for each of her children. These she would decorate with the family's bees wax and various dyes made from bark, flowers, peels and berries. The eggs were placed in Easter baskets which were typically hidden in the barn.

In the late 1930s when she was about seven years of age, Betty began learning to decorate eggs from her mother. She learned the basic techniques for making *krizanki*, as well as the symbolic significance of the dyed eggs. Stella taught her daughter that the eggs were a way of welcoming the spring, of expressing gratitude for having survived the winter, and of hoping for flowers and a good harvest. She also told stories about the use of the eggs in the Old Country. While Stella Piso made an occasional two-colored egg, she did not have the tools or the knowledge required to make more elaborate Ukrainian Easter eggs, called *pysanky*. She did, however, describe for her children examples of these jewel-like creations which she had seen.

In 1974, after approximately thirty-five years of making *krizanki*, Betty Christenson finally saw examples of fancier Ukrainian *pysanky* while visiting relatives in Canada. Drawing upon these observations, as well as publications and materials purchased at a Ukrainian specialty shop in Minneapolis-St. Paul, Christenson undertook mastering the creation of the more elaborately decorated eggs. The process is an intricate one. *Pysanky* means "writing," and designs are first penciled onto the eggs. Then a *kistka*, a tool with a beeswax-filled funnel tapering into a stylus, is heated so that the melted wax can be applied between the pencil lines. The surfaces which will remain white on the finished egg are the first covered with wax. Subsequently, the egg is dyed and the areas of this color which the artist wishes to

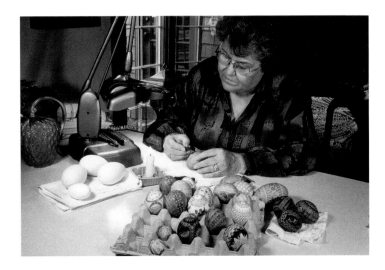

BETTY PISO CHRISTENSON

SURING, WISCONSIN

preserve are then covered with wax. The process is repeated, proceeding from the lightest to the darkest dye, until the egg is completely coated with wax. The layers of wax are then melted away and the finished egg remains to be varnished and dried.

Over the past twenty years, Betty Christenson has gained a high level of accomplishment in her new art form. She has made beautiful *pysanky* for every sibling, child and grandchild in her family. She also teaches classes and workshops on a regular basis. Her eggs have even been transported to relatives in the Ukraine, where the traditional practice of decorating Easter eggs has declined markedly but where the eggs remain a powerful symbol of religious belief and ethnic identity.

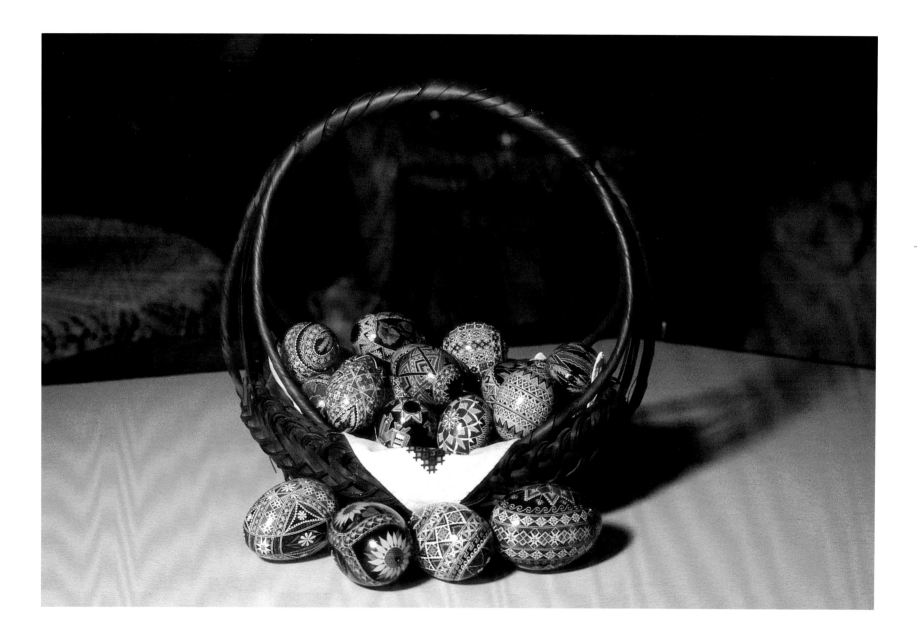

■ BASKET FILLED WITH UKRAINIAN *PYSANKY* BY BETTY PISO CHRISTENSON.

CHECKLIST OF THE EXHIBITION

SLOVAK:

SIDONKA WADINA LEE
House Blessings
1993
Wheat, woven; c. 16" x 7" x 2"

SIDONKA WADINA LEE
Harvest Cross
1993
Wheat, woven; c. 23" x 15" x 4"

SIDONKA WADINA LEE
Straw-Decorated Easter Eggs
1993
Eggs, colored with commercial dyes;
straw, slit and glued;
c. 4.5" x 2.5" diameter

SIDONKA WADINA LEE
Collectors Plate
1993
Wood, painted

DANISH:

INGA HERMANSEN
Bell Pull
1993
Linen, cross-stitch embroidery;
35.5" x 6"

INGA HERMANSEN
Dresser Scarf
1993
Linen, cross-stitch embroidery;
36" x 14"

INGA HERMANSEN
Heart and Cone Christmas Ornaments
1993
Crocheted; linen, cross-stitch embroidery;
4" x 3" to 5" x 3" x 3"

ALBERT LARSEN
Heart Baskets
1993
Glossy wrapping paper, cut and woven;
.75" x .50" to 7.5" x 4.75"

SLOVENIAN:

JOHN BAMBIC
Butcher Shop Whirligig
1993
Wood, carved and painted;
16" x 10" x 9.5"

JOHN BAMBIC
Butter Churning Whirligig
1993
Wood, carved and painted;
16" x 7" diameter

AFRICAN-AMERICAN:

ALLIE CRUMBLE
Star Quilt
1990s
Cotton/polyester blends, hand-pieced and
hand-quilted;
95" x 72"

IVORY PITCHFORD
String Star Quilt
1990
Cotton/polyester blends, hand-pieced and
hand-quilted;
92" x 92"

HISPANIC:

BERTA MENDEZ
Heart Pinata
1993
Papier mache, tissue paper;
36" x 12" x 5"

BERTA MENDEZ
Paper Flowers
1993
Tissue paper, dowels;
22" x 8" x 4" to 42" x 14" x 8"

MANUEL REYES
Parrot, Squirrel, Rooster,
 Chicken and Woodpecker
1990s
Wood, carved and painted;
4" x 2" x 3" to 5.5" x 10" x 2"

ARMENIAN:

ELIZABETH KEOSIAN
Armenian Needle Lace Doily
c. 1960s
DMC embroidery thread;
12" diameter

ELIZABETH KEOSIAN
Armenian Needle Lace Doily
c. 1960s
DMC embroidery thread;
11.5" diameter

POLISH:

"BERNIE" JENDRZEJCZAK
Leluje or "Lily" (Kurpie Region)
1993
Wrapping paper, folded and cut;
10" x 5" each

"BERNIE" JENDRZEJCZAK
Kolka or "Circle" (Kurpie Region)
1993
Wrapping paper, folded and cut;
13" diameter

"BERNIE" JENDRZEJCZAK
Gwiazda or "Star" (Lowicz Region)
1993
Wrapping Paper, folded and cut;
11.5" to 14.75" diameters

"BERNIE" JENDRZEJCZAK
Kwadrat or "Square" (Lowicz Region)
1993
Wrapping paper, folded and cut;
11" x 11"

"BERNIE" JENDRZEJCZAK
Greeting Cards
1993
Wrapping paper, folded and cut;
4" x 6" each

GERMAN:

TRINITY EVANGELICAL LUTHERAN
 CHURCH BAND
Bass and Alto Horns
c. 1900–1950
Brass; 32" x 23" x 18" and 18" x 16" x 11"
Loaned by the
 Trinity Historical Society, Freistadt

FREISTADT ALTE KAMERADEN BAND
Publicity Photographs, Posters, Programs
c. 1950s–1990s
Loaned by the
 Trinity Historical Society, Freistadt

DUTCH:

ROBERT SIEGEL, JR.
Wooden Shoes
1990
Aspen, hand-shaped;
4" x 3.5" x 9" each

WILLIAM KLOMPENHOUWER
Wooden Shoes
c. 1950s–1960s
Basswood, hand-shaped,
 stained and varnished;
5" x 4" x 11.5" each
Loaned by Elwood Klompenhouwer

LARRY WIEBERDINK
Shoemaker's Workbench and Tools,
 Wooden Shoes
Tools: 1900–1950;
 Bench and Shoes: 1970s
Basswood and aspen, metal;
Bench: 27" x 54" x 23"
Loaned by Larry Wieberdink

HMONG:

XAO YANG LEE
Baby Carrier
1993
Cotton/polyester blends, applique,
 cross-stitch embroidery;
23.5" x 17" excluding sash

XAO YANG LEE
"Hmong People"
1993
Cotton/polyester blends,
 cross-stitch embroidery; 17" x 17"

XAO YANG LEE
Story Cloth
1990s
Cotton/polyester blends, applique,
 embroidery; 34" x 36"

XAO YANG LEE
Paj Ntaub
1990s
Cotton/polyester blends, applique,
 reverse applique, embroidery; 18" x 33"

XAO YANG LEE
Wallet, Eyeglass Case, Necklace,
 Pin Cushions, Button
1990s
Cotton/polyester blends, reverse applique,
 embroidery; 4" x 7.5" to 1.5" diameter

KAI YANG LEE
Animal Figure Batik
1990s
Cotton, batik
24" x 36"

ONEIDA:

PRISCILLA MANDERS
"Low-knot-goo-soul" ("Healing Ritual")
1993
Cornhusk dolls, herbs, natural materials;
18" x 46" x 24"

CZECH:

JOSEPH SHEFCHECK
Small Feed Basket
1980s
Black ash, split and woven;
20" x 17" x 16.5"
Loaned by William Tishler

JOHN ARENDT
Laundry Basket
1990s
Black ash, split and woven;
12" x 18" diameter

UKRAINIAN:

BETTY PISO CHRISTENSON
Ukrainian Easter Eggs
1993
Eggs dyed using wax resist
 method, shellac; 1" x 1" to
 3.5" x 2.25" diameter

Complementing the artifacts featured in
the exhibition are field photographs by
Lewis Koch and James P. Leary. All objects
are from the collection of the Cedarburg
Cultural Center unless otherwise indicated.
Dimensions are indicated height x width x depth.

PHOTO CREDITS

All photographs included in this publication, unless otherwise
indicated below, are copyright Lewis Koch and used by permission.

Lewis Koch, Courtesy of the Wisconsin Folk Museum: Pg. 34, 35, 43.

Alan Pape: Pg. 10.

James P. Leary: Pg. 14, 17, 18, 23, 45.

James P. Leary, Courtesy of the
 John Michael Kohler Arts Center: Pg. 50.

Janet C. Gilmore, Courtesy of the
 John Michael Kohler Arts Center: Pg. 39.

Courtesy of Robert Siegel, Jr.: Pg. 45.

Courtesy of Elwood Klompenhouwer: Pg. 44.

Courtesy of the Trinity Historical Society, Freistadt: Pg. 42.

Max Fernekes, from *Old World Wisconsin:
 Around Europe in the Badger State* by
 Fred L. Holmes (Eau Claire: E.M. Hale and Company, 1944): Pg. 44.